40

Abe Frajndlich Portraits

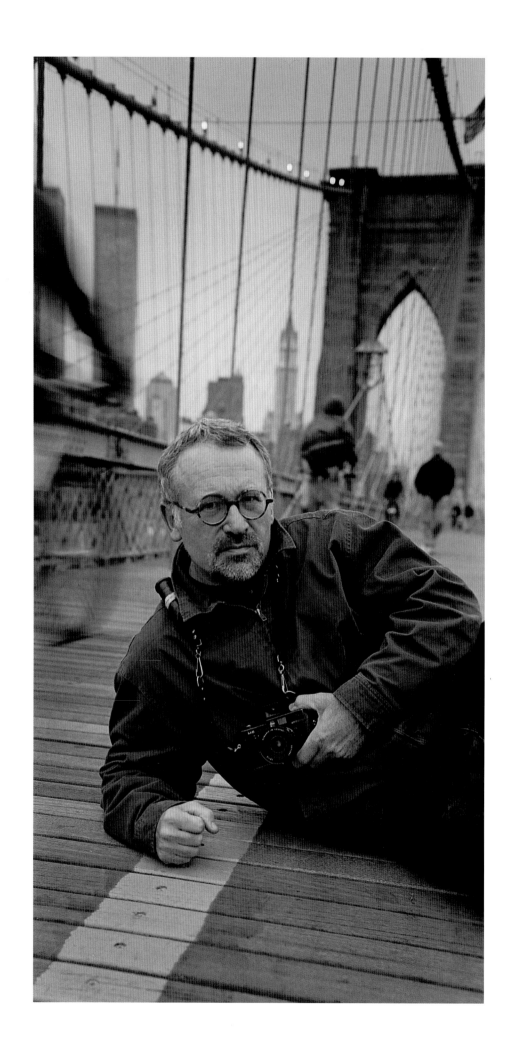

Abe Frajndlich

Portraits

With an Introduction by
Phoebe Hoban

Prestel
Munich · London · New York

Cover: Jack Lemmon
Frontispiece: Abe Frajndlich, Brooklyn Bridge,
New York City, June 13, 2000.
Photograph by Lucas Frajndlich.
Back cover: Roy Lichtenstein

Library of Congress Catalog Card Number: 00-190986

© Prestel Verlag, Munich · London · New York, 2000
© all photographs by Abe Frajndlich

Prestel Verlag
Mandlstrasse 26 · 80802 Munich
Tel. +49 (089) 381-7090, Fax +49 (089) 381-70935

4 Bloomsbury Place · London WC1A 2QA
Tel. +44 (20) 7323-5004, Fax +44 (20) 7636-8004

16 West 22nd Street · New York, NY 10010
Tel. +1 (212) 995-2720, Fax +1 (212) 995-2733

www.prestel.com

Prestel books are available worldwide.
Please contact your nearest bookseller
or one of the above Prestel offices for details
concerning your local distributor.

Editorial direction by Claudine Weber-Hof

Copyedited by Jane Milosch, Munich
Design and typography by Iris von Hoesslin, Munich
Lithography by Repro Ludwig, Austria
Printed by Sellier Druck GmbH, Freising
Bound by Almesberger GmbH, Austria

Printed in Germany on acid-free paper

ISBN 3-7913-2406-3

Special artist's edition available from
the photographer at abefoto@aol.com
ISBN 3-7913-2465-9

Contents

Portraiture in Pantomime

Phoebe Hoban

If photography captures a moment, Abe Frajndlich's portraiture choreographs one. The images in this book are not so much reflections of their subjects as reflections on them: loaded but often humorous studies of subjects engaged in a kind of photographic pantomime. Take Roy Lichtenstein (p. 57) hiding behind a giant brush as if playing charades with the viewer. Even someone unfamiliar with the famous contemporary artist would have little trouble receiving the picture's message, telegraphed in boldface: this person is, first and foremost, a painter. And not just any painter, but a painter of magnitude, judging by the size of the brush.

But Frajndlich further layers this image with nuanced references for the cognoscenti. The brush in this instance is a wall-paper brush, alluding to the period when Lichtenstein supported his family by doing wall-paper for his wife's decorating business.

"I don't just arbitrarily use props, the props refer to the person's ouevre. Photography becomes very mimetic," Frajndlich explains. "The simplest gesture can describe somebody. You get into a kind of child-like play that connects you to your primal self."

Play—in all its various meanings—is a key word in Frajndlich's technique. Frajndlich's work communicates the truth, but his camera is not candid; rather it focuses on the subject's essence by artfully playing with appropriate imagery. Call it visual semiotics.

There's Jeremy Irons (p. 85), putting on make-up before going on stage as Richard the Third at Stratford-on-Avon. Bathed in a mythic, golden light, he is seen as a reflection in a mirror, in the margin of which is hung a portrait of the Bard himself—as well as a photograph of his idol, Sir Laurence Olivier. "All the world is a stage," says this picture. "And all the men and women merely players."

Frajndlich doesn't preconceive his portraits, rather, he allows them to happen. "I approach each subject by trying to get as much information as I can beforehand. But I don't really visualize what I am going to do until I get there. I go to the job blank. I have no idea what I might find or what kind of chemistry there might be with the subject," he says.

Still it can't hurt to court serendipity. Not many photographers would have arrived at a shoot with the Hollywood legend Jack Lemmon equipped with a paper bag full of lemons. "I was getting ready to do that shoot in a white studio. And I thought, Okay, I'm going to do something really stupid or maybe something that might just work. I'll bring lemons. And either he'll say forget it, or he'll go along with it. He said, 'I've been photographed for 55 years, and no photographer has ever brought lemons to a shoot before. Do whatever you want.'" The resulting image speaks for itself (p. 37).

Sometimes, Frajndlich conjures up ghosts; see the late Isaac Singer (p. 18), hovering like an apparition in Miami Beach, his face shaded in sunglasses, his body shaded by an umbrella, his very being shaded by the evocative Rorshach-like blots on the wall behind him. Every picture tells a story, and Frajndlich is happy to share this one. "I saw that wall just at the end of the first day's shooting, when it was getting dark," he says. "It started raining, and rained all night, which it rarely does in Miami. I knew I needed that image to complete the story, so the next morning we went back to that wall. The rain had ended, but he still had his umbrella. The rain stains on the wall vaguely refer to a golom—a mythic creature in Yiddish folklore that plays a role in many of Singer's stories."

Frajndlich's seize-the-moment approach derives from his years with his mentor, the noted photographer Minor White (1908–1976), who studied the teachings of the Russian philosopher and mystic George Ivanovich Gurdjieff. "If there is anything I learned from Minor, it's that when you go into a situation with a new person, be there. Minor always stressed the importance of staying awake. To be aware and present was essential."

Perhaps because Frajndlich is so open to his subjects, they open up for him. And many of them clearly appreciate his knowledge of their work. The artist James Rosenquist (p. 32) is depicted peering out from behind a clothesline festooned with bacon. "Rosenquist did a number of huge works that had slabs of bacon in them," says Frajndlich. "It's a direct reference to the series that included 'Evolutionary Balance' and 'Star Thief,' 1980."

Frajndlich began his career with an unlikely degree: an M.A. in literature from Northwestern University. But he always felt that he would never attain entry to the literary club that included his heroes—such writers as James Joyce, Samuel Becket and Jean Genet. "I was sitting in the library on a beautiful spring day doing ibids and op. cits. and I suddenly realized that twenty-five years later, I was going to be doing exactly the same thing. I walked out without much of an idea of what to do, but a friend had a darkroom, and I moved back to my hometown, Cleveland, and started making pictures. Photography, unlike literature, was a medium you could come to terms with."

But Frajndlich's real epiphany came when he met Minor White, who had come to Cleveland to do a workshop. White soon became his photographic father figure, and, although he told the aspiring photographer that his pictures were "awful," he invited his young admirer to come study with him at his house in Boston.

"My first job was to organize his library," recalls Frajndlich,"and through that I discovered all these photographers. Before then I had no idea about Cartier-Bresson, Kertesz, or Weston. But what Minor really did for me was to tune me into listening to my own voice. A lot of people work by rote—he encouraged me to constantly question and rebel. He asked

me what I wanted to do and I said, 'take pictures,' and he said, 'go take pictures.' It was like being at some Zen master's house where the obvious is the real answer."

Frajndlich's first book, *Figments* (1975), edited by White, is a series of photographs of, not surprisingly, a mime named Rosebud Conway (1950–1978). For Frajndlich, *Figments* was a visual *bildungsroman*. His second book, *Cleveland Infra Red* (1981), transforms his adoptive city into a town saturated with energy. Seven years after White's death, Frajndlich published a tribute to his friend and teacher, called *Lives I've Never Lived* (1983).

During the 1980s Frajndlich became a commercial photographer, shooting pictures for such publications as *The New York Times Magazine*, *The London Observer*, and *Life*. He was also a regular contributor to the German weekly, *Frankfurter Allgemeine Zeitung Magazin*. (In 1999, *Eros Eterna*, a book spanning thirty years of his work with the nude, was published in Germany.)

Thanks to his many images of famous cultural figures—from Dennis Hopper to Leo Castelli to Cindy Sherman—Frajndlich quickly made a name for himself as the artists' photographer. Looking through his work is like paging through a pop-cultural Who's Who: there's a brooding portrait of William S. Burroughs, an antic picture of architect Frank Gehry, a dapper Saul Bellows in a pin-stripe suit, Billy Wilder against a mural of Hollywood stars, Andy Warhol at a Richard Avedon opening. "Each subject, each stranger, becomes a seduction," says Frajndlich of this impressive gallery of icons. "As a photographer you are asked to interpret an artist you have only met through his (or her) work. Whether it's getting a Nobel-prize winning author to kid around with you, or a photographer known for her own unique images to relinquish control, you have to get your subjects to trust you. They must feel comfortable enough to be totally vulnerable. It's almost like getting them to undress, to completely reveal themselves, so you can explore parts of them that the public never sees. Ultimately, taking a picture is an intimate collaboration—a true seduction."

In this embarassment of photographic riches, does Frajndlich have a favorite picture? He pauses before answering. "The one I haven't made yet."

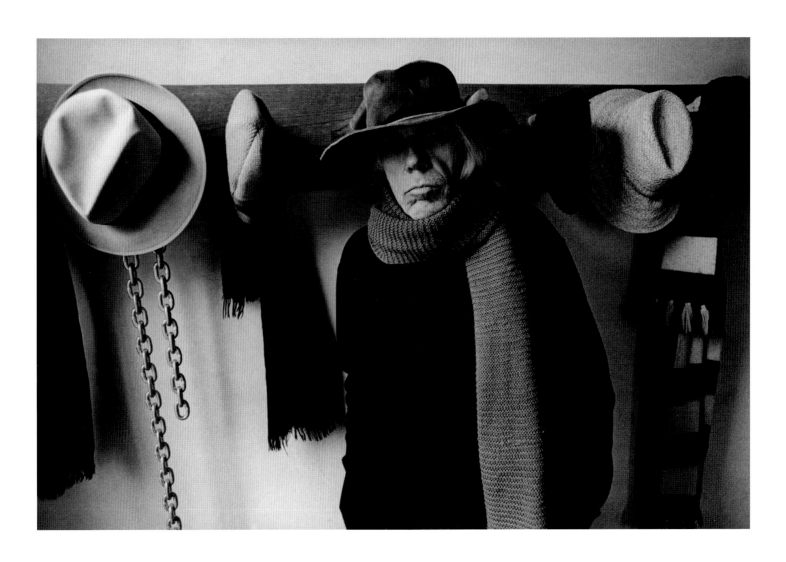

Minor White, photographer. Arlington Heights, Massachusetts, March 21, 1976

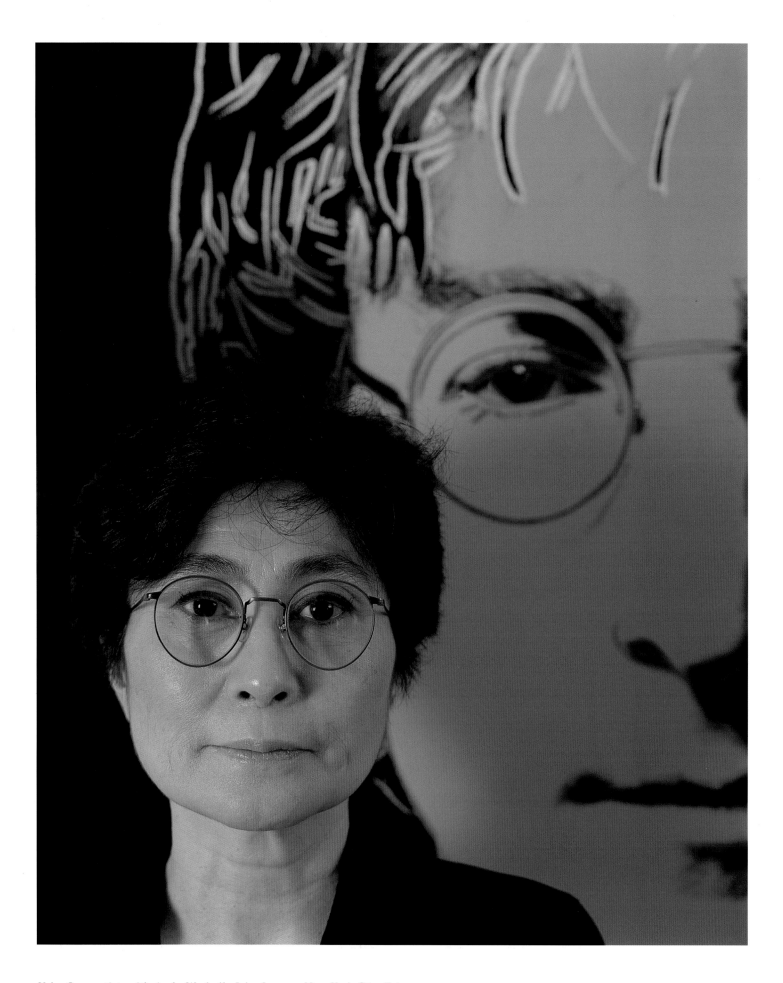

Yoko Ono, artist, with Andy Warhol's *John Lennon*. New York City, February 21, 1994

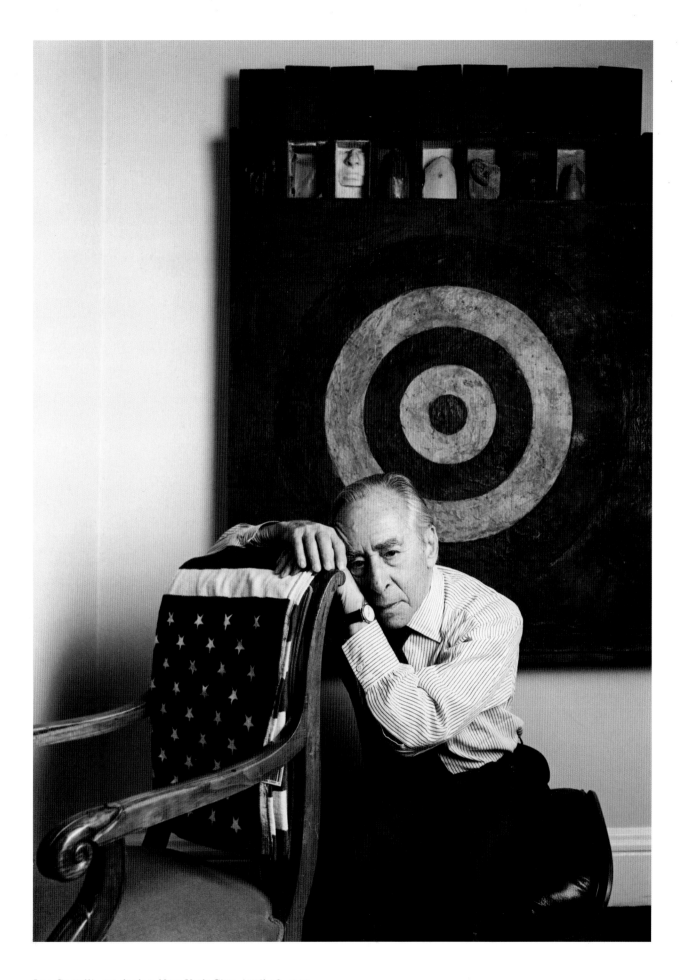

Leo Castelli, art dealer. New York City, April 28, 1992

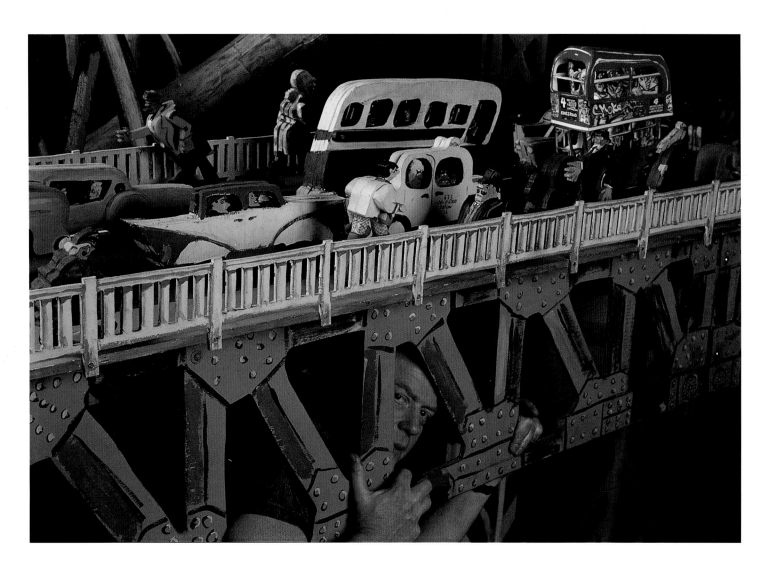

Red Grooms, artist. Los Angeles, March 12, 1986

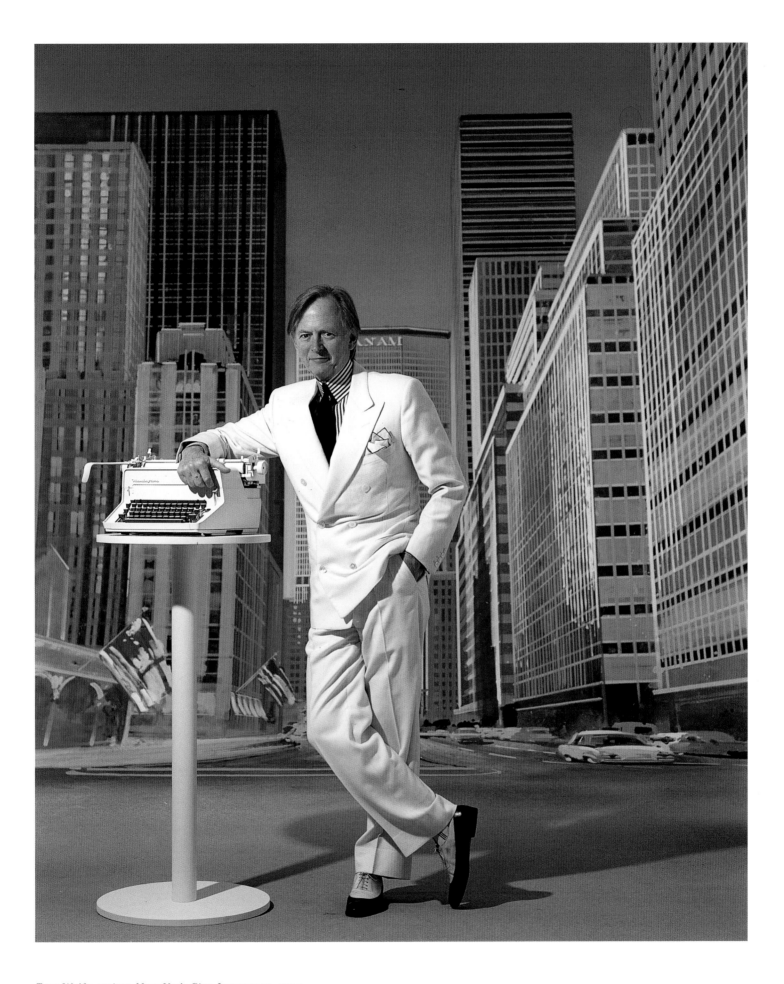

Tom Wolfe, writer. New York City, January 11, 1990

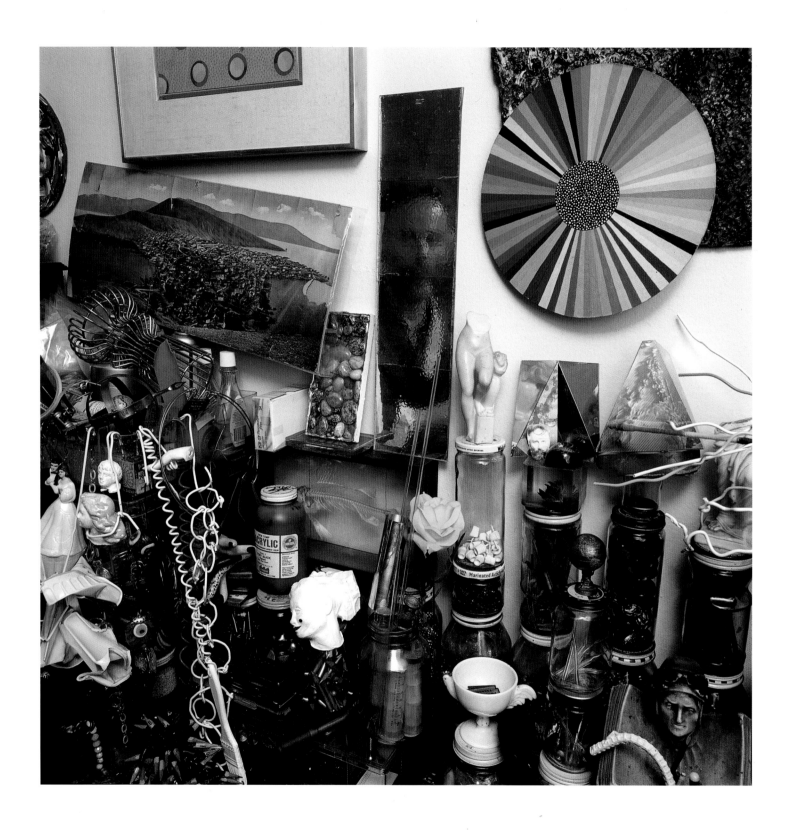

Lucas Samaras, artist. New York City, September 9, 1986

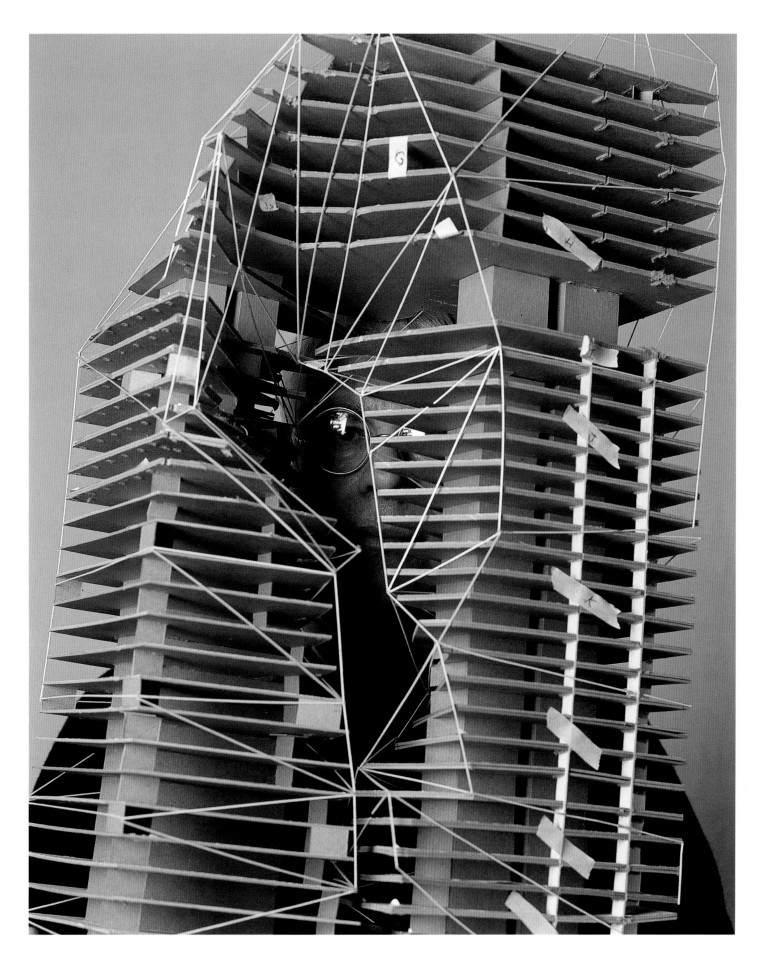

Peter Eisenman, architect. New York City, January 28, 1993

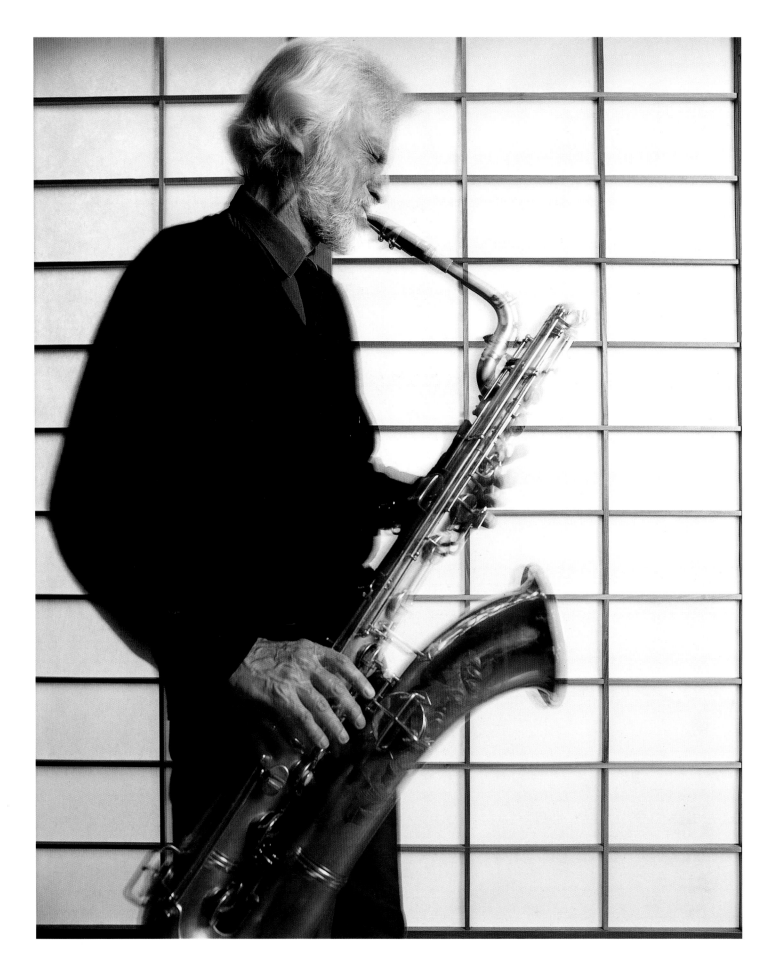

Gerry Mulligan, jazz saxophonist. Wilton, Connecticut, April 8, 1995

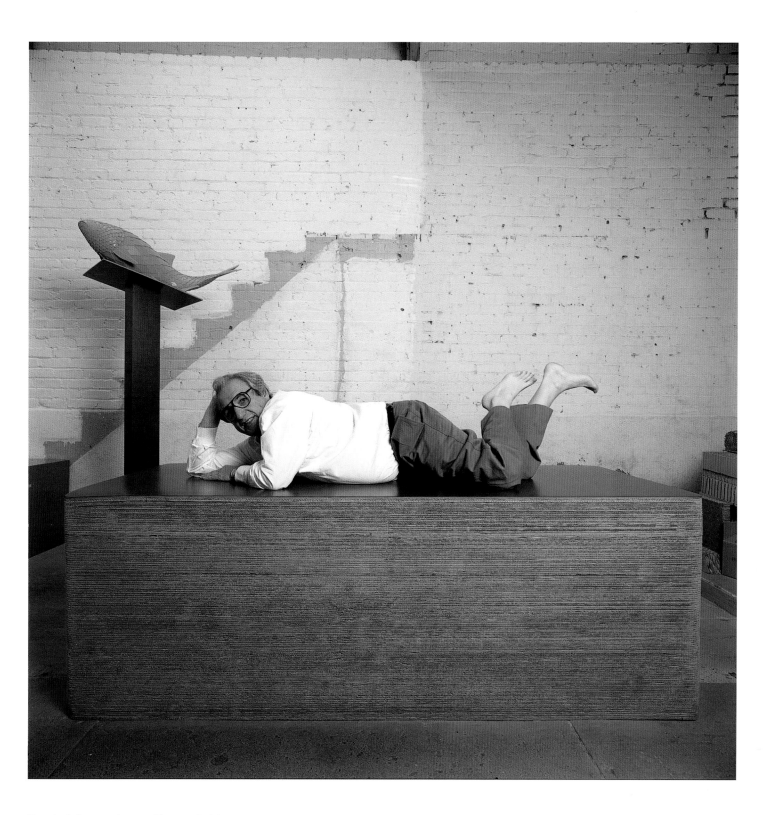

Frank Gehry, architect. Venice, California, November 17, 1987

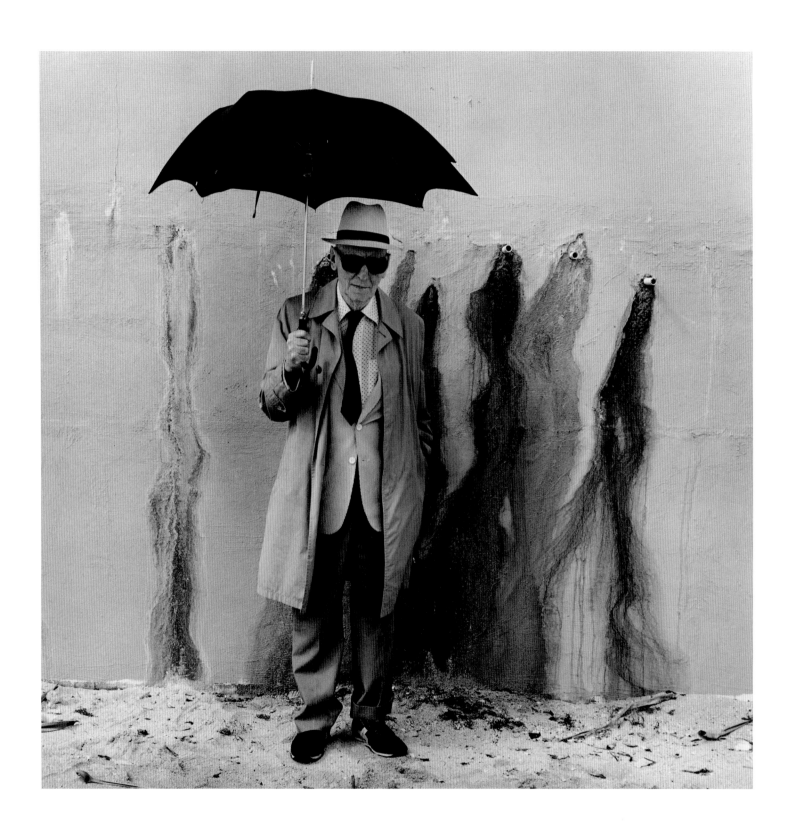

Isaac Singer, Yiddish writer. Miami Beach, Florida, February 13, 1986

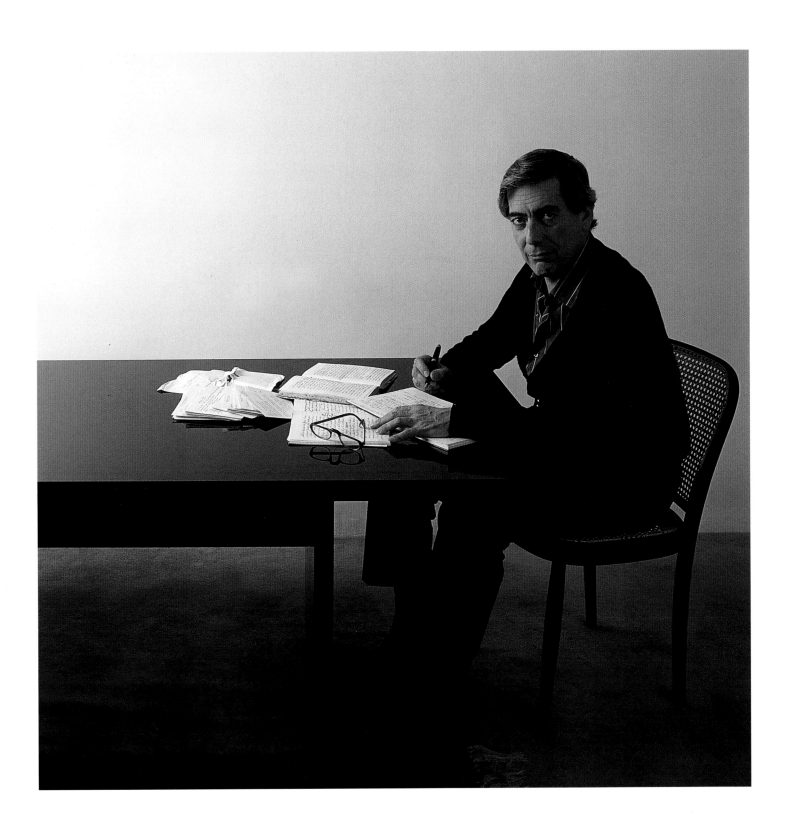

Mario Vargas-Llosa, writer. London, November 20, 1986

Elie Wiesel, Holocaust writer. New York City, July 2, 1985

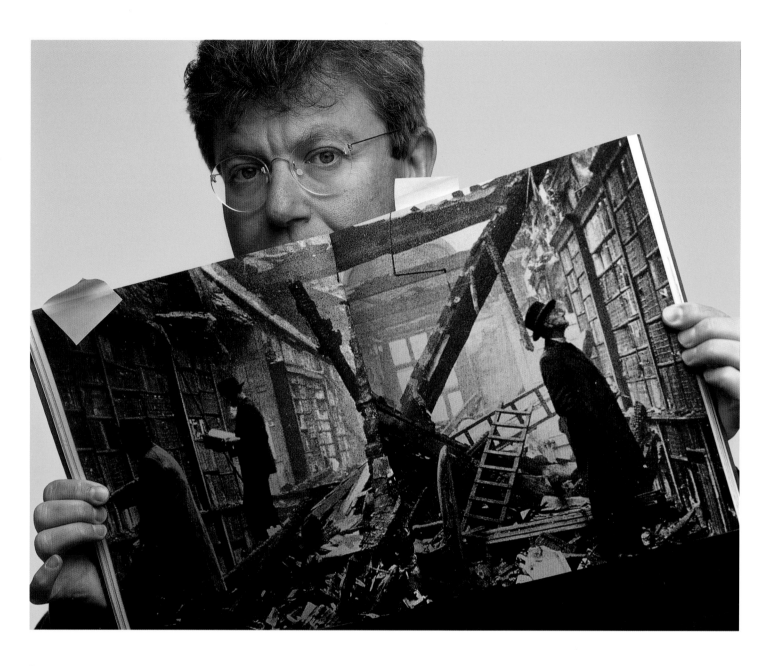

Daniel Libeskind, architect. Los Angeles, April 17, 1995

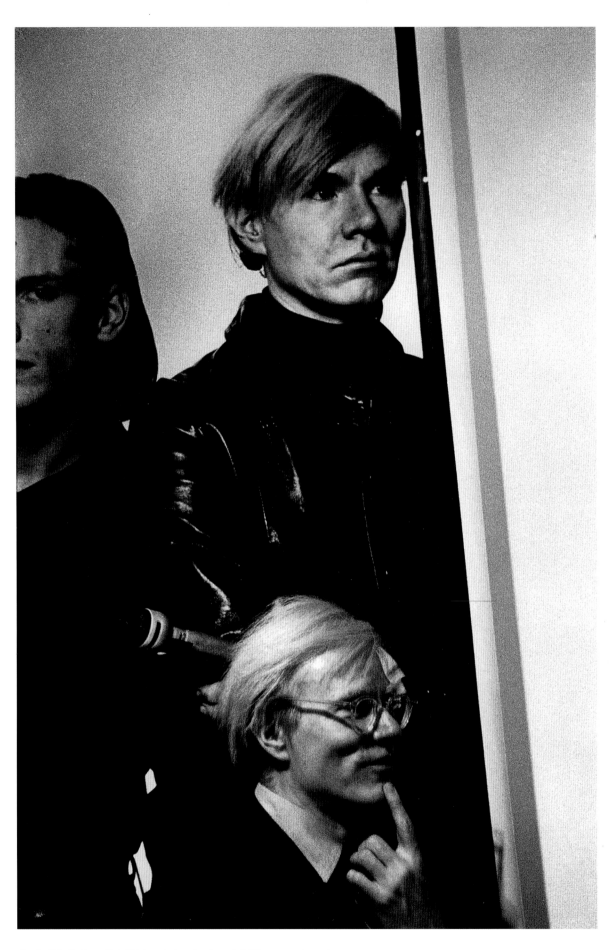

Andy Warhol, artist. Richard Avedon's exhibition opening at
Marlborough Gallery, New York City, September 9, 1975

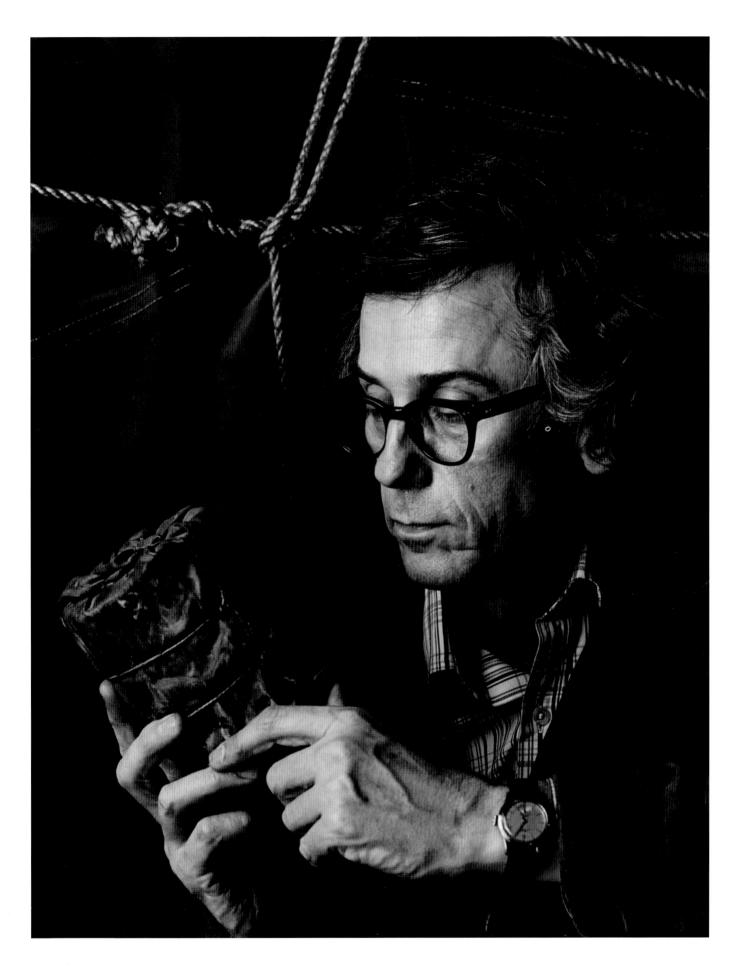

Christo, artist. New York City, January 4, 1986

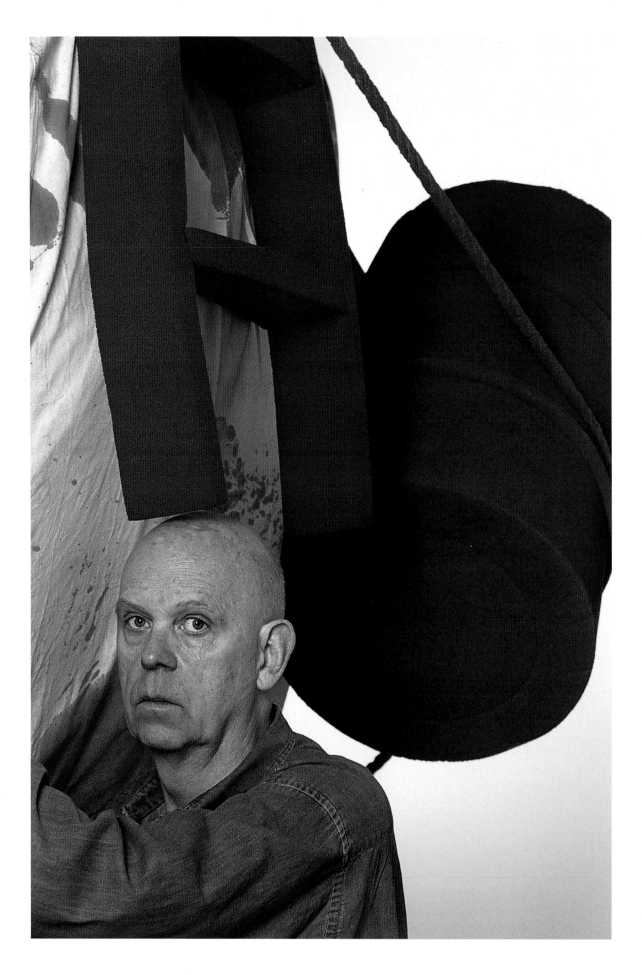

Claes Oldenburg, artist. January 4, 1990

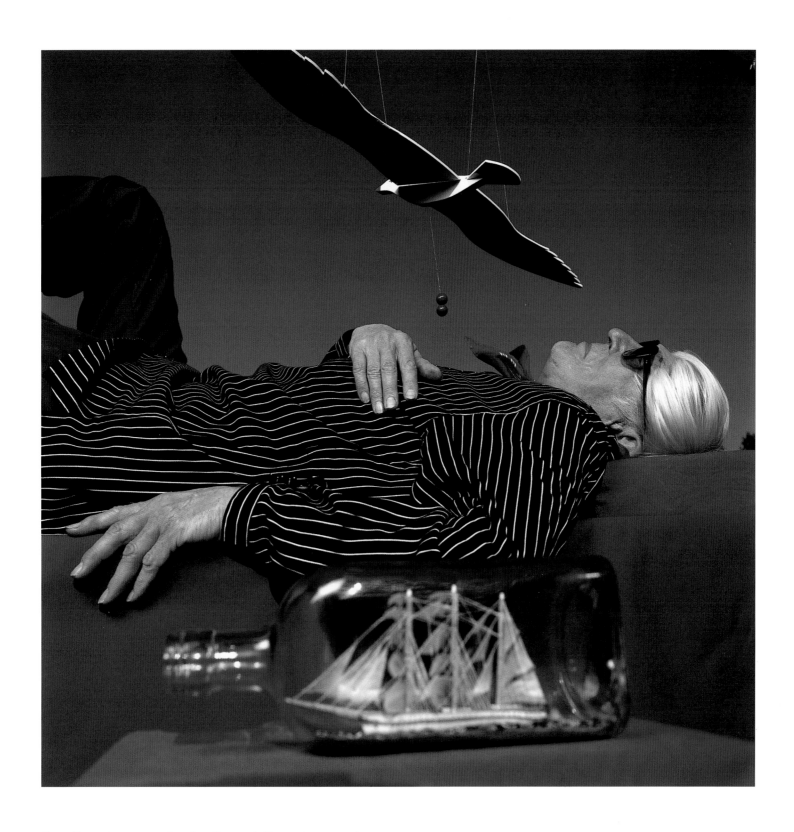

Fritz Grassof, writer and artist. Montreal, September 24, 1989

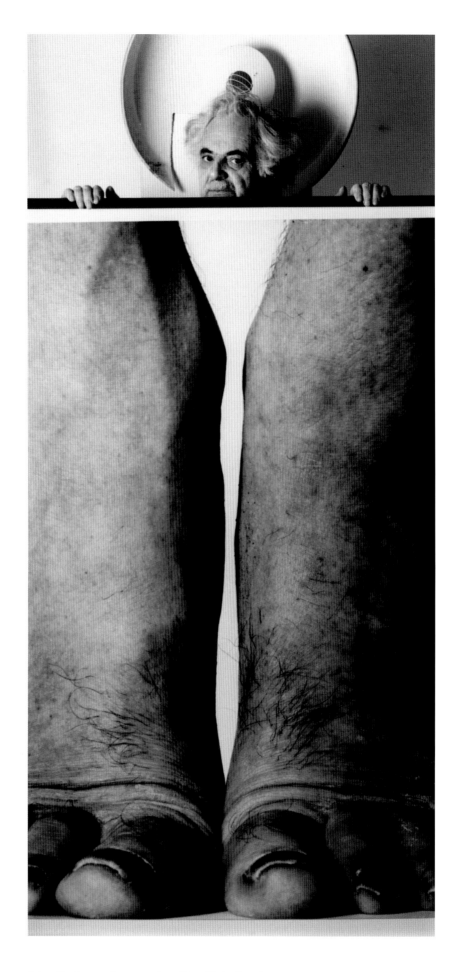

John Coplans, photographer. New York City, December 23, 1988

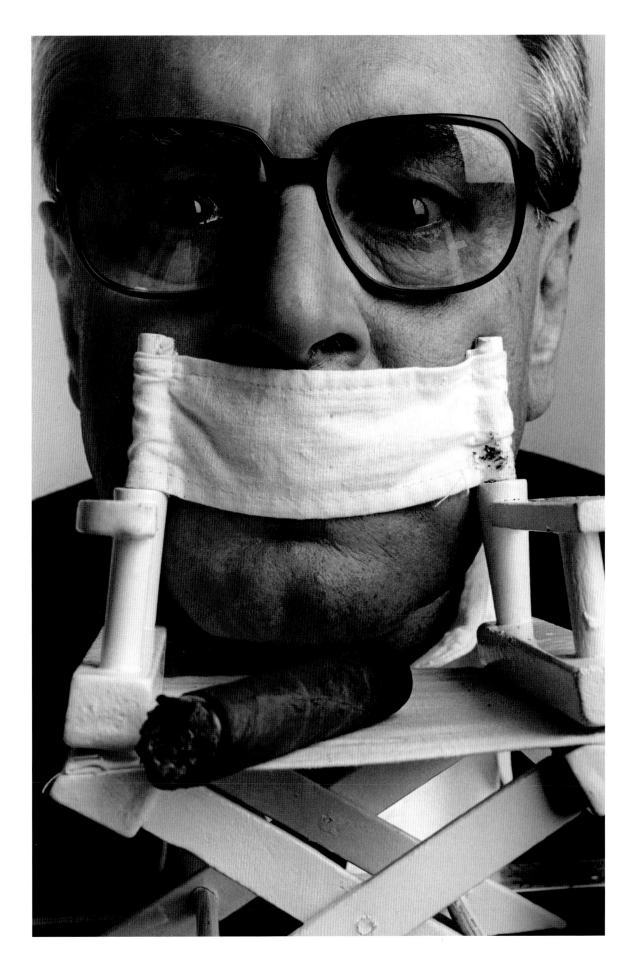

Milos Forman, director. Hollywood, January 24, 1997

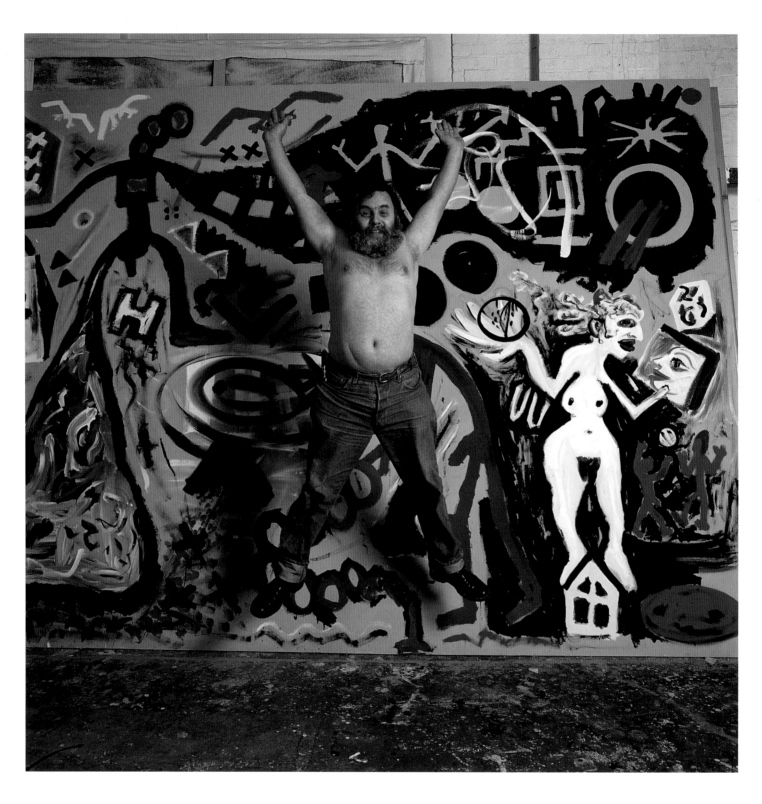

A.R. Penck, artist. London, November 22, 1986

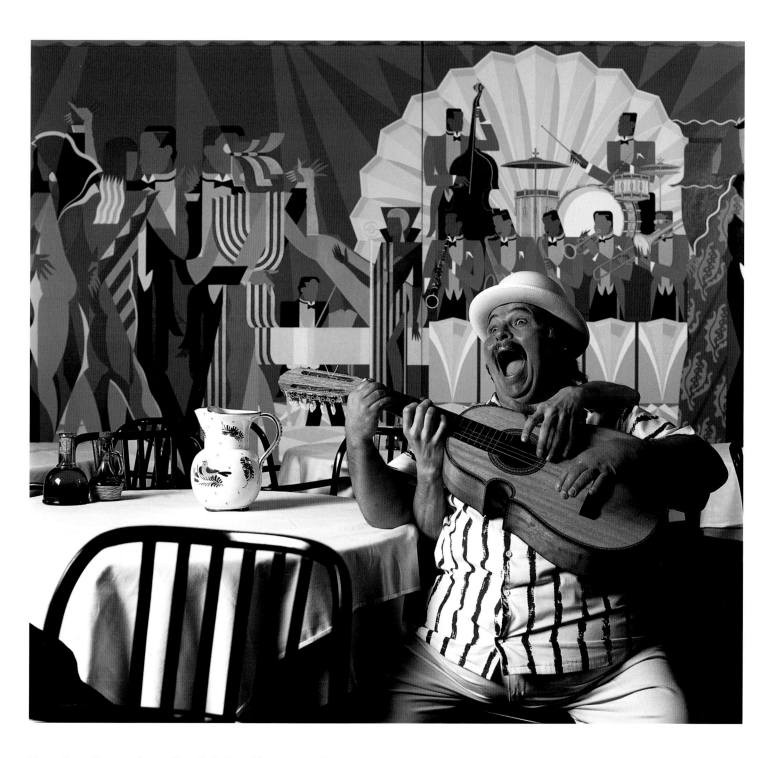

Yomo Toro, Quatro player. New York City, March 14, 1988

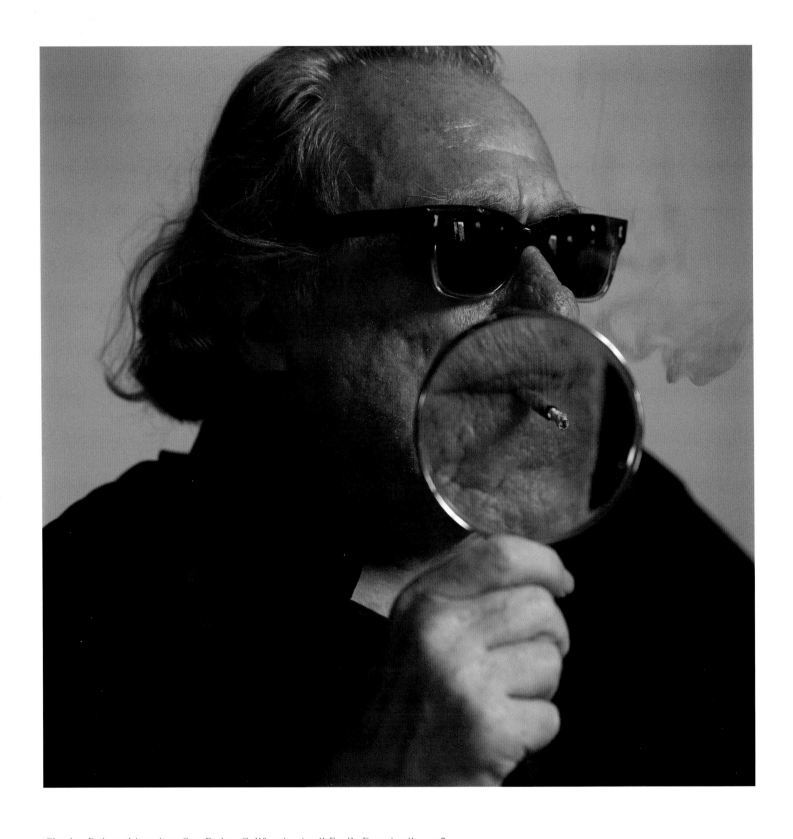

Charles Bukowski, writer. San Pedro, California, April Fool's Day, April 1, 1985

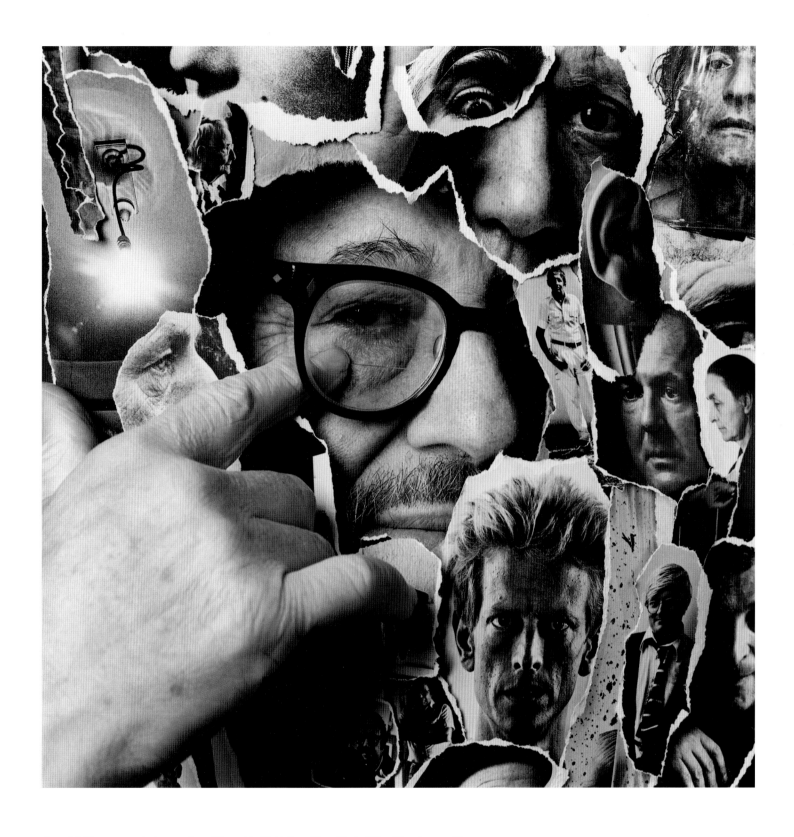

Arnold Newman, photographer. His 70th Birthday, New York City, March 3, 1988

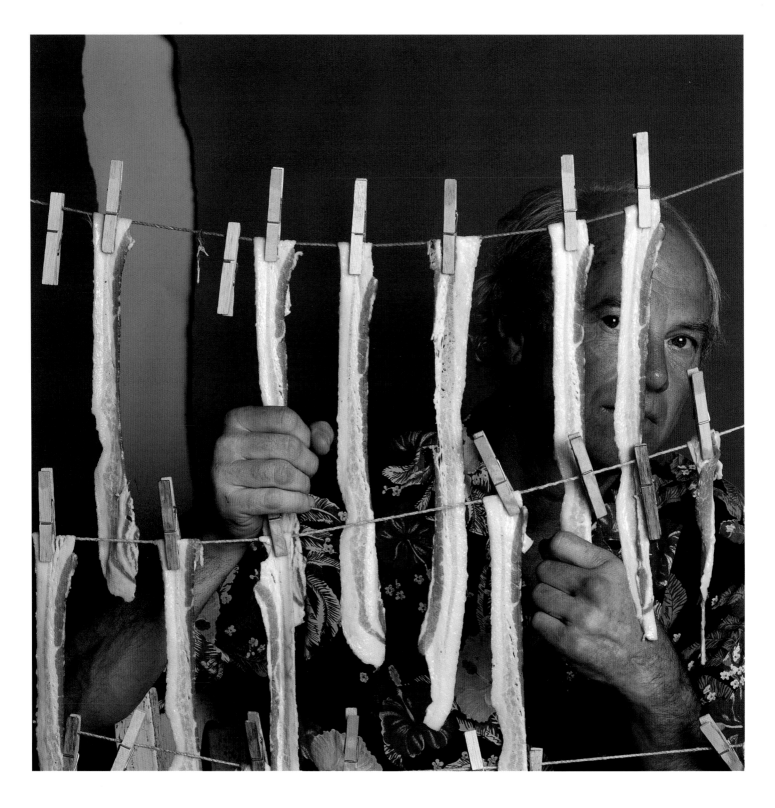

James Rosenquist, artist. Aripeka, Florida, June 13, 1986

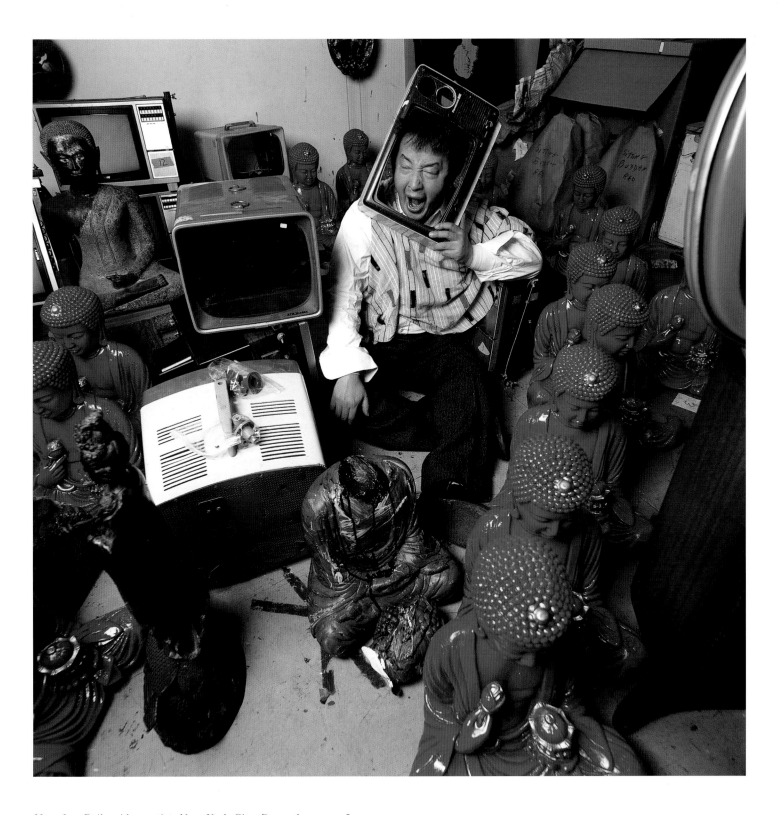

Nam Jun Paik, video artist. New York City, December 11, 1989

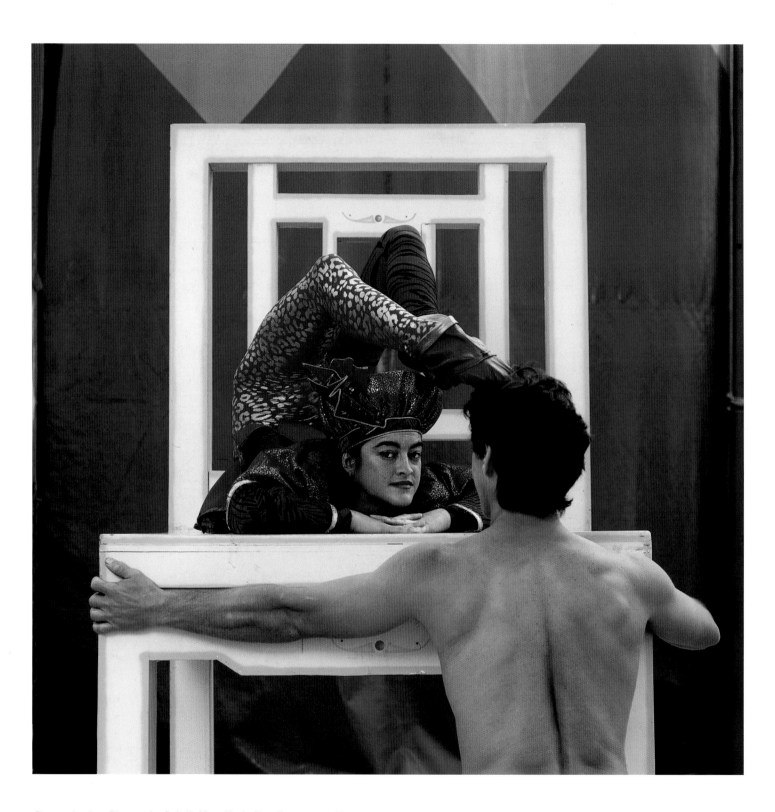

Contortionist. Cirque du Soleil, New York City, June 12, 1988

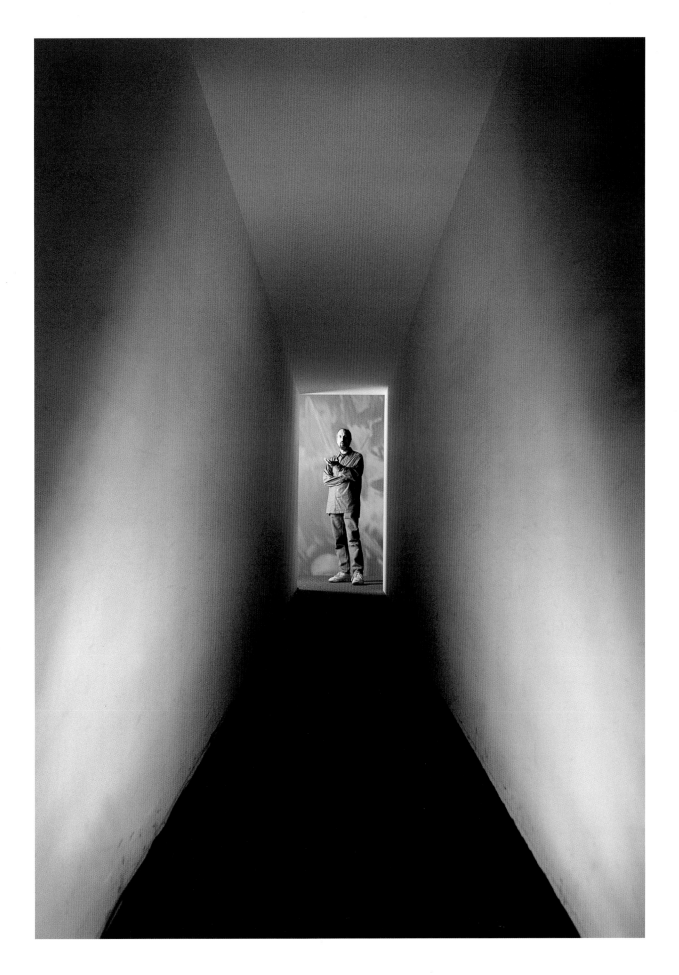

Bill Viola, video artist. Whitney Museum of American Art, New York City, May 4, 1998

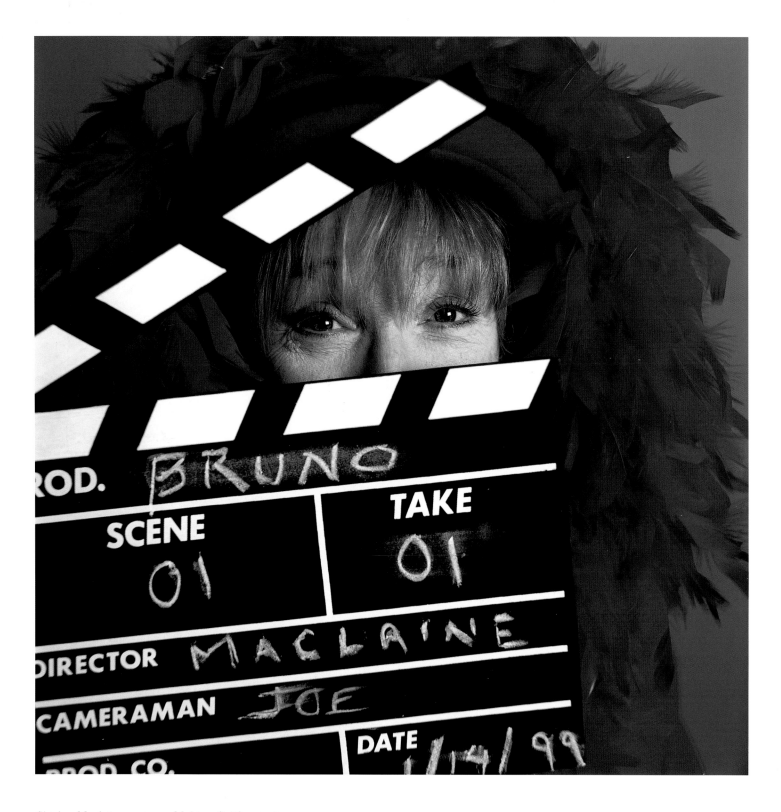

Shirley Maclaine, actress. Malibu, California, January 14, 1999

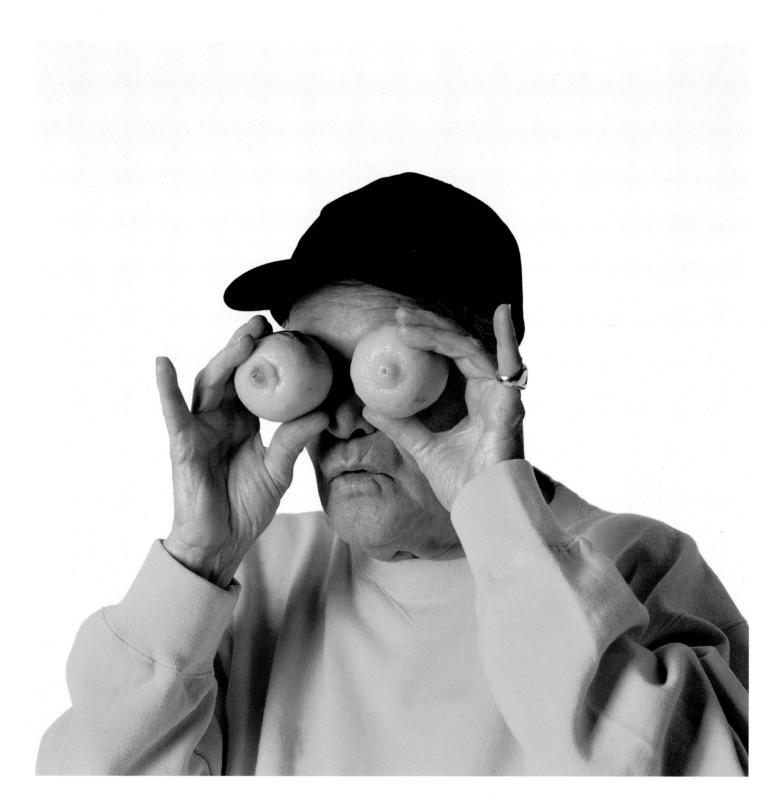

Jack Lemmon, actor. Hollywood, January 15, 1996

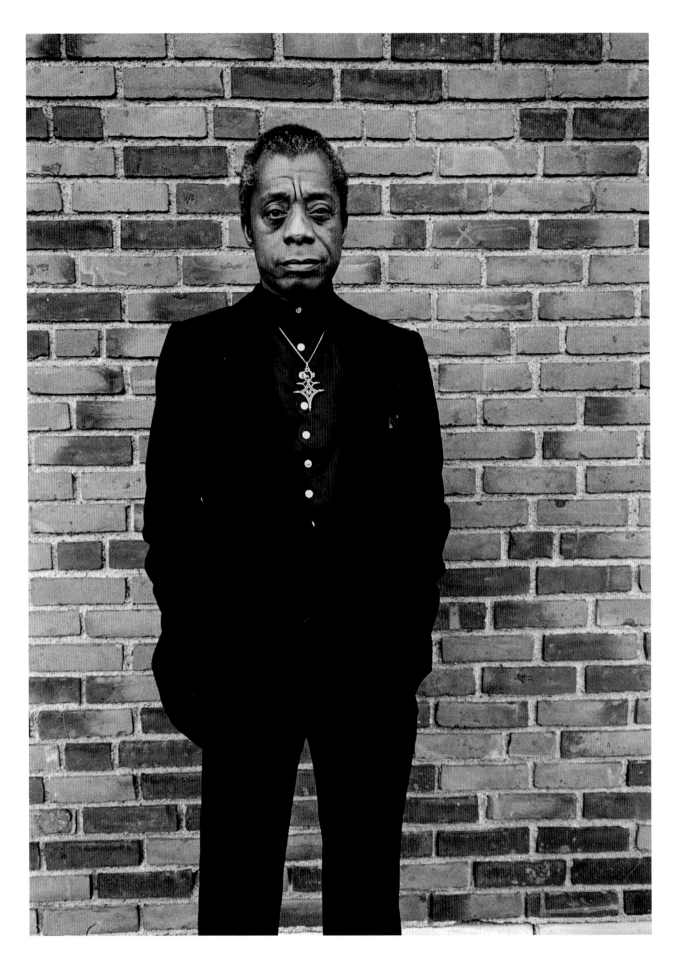

James Baldwin, writer. Cleveland, Ohio, October 9, 1978

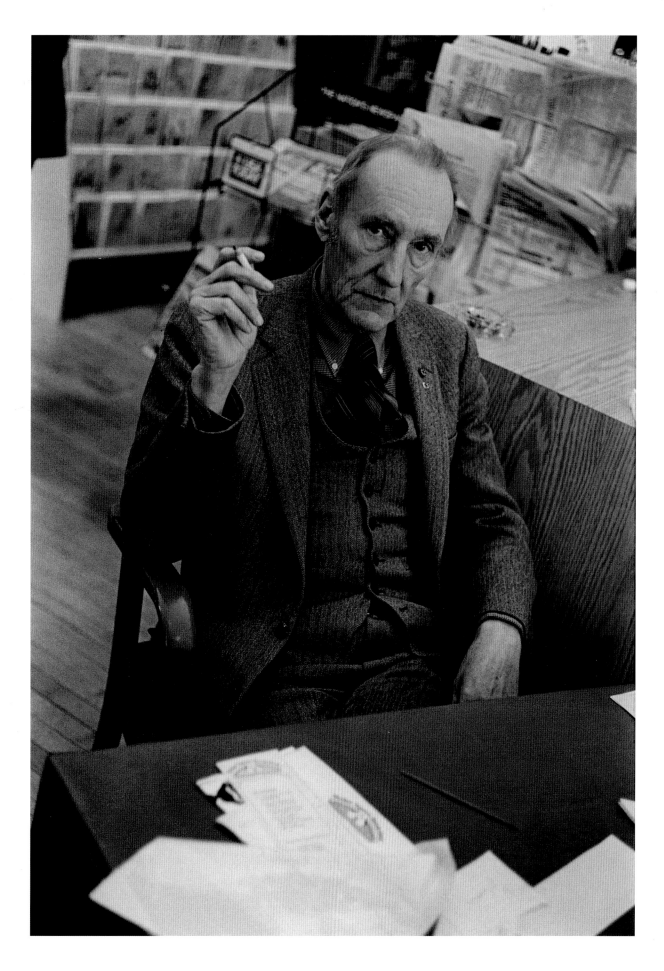

William Burroughs, writer. Cleveland, Ohio, April 11, 1984

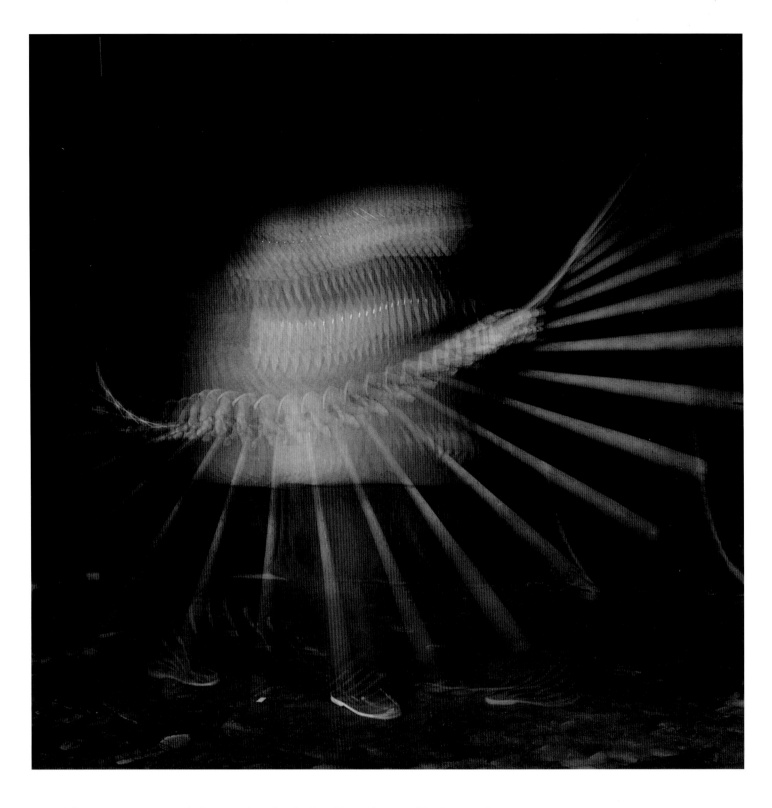

Harold Edgerton, inventor and photographer. Cambridge, Massachusetts, March 15, 1986

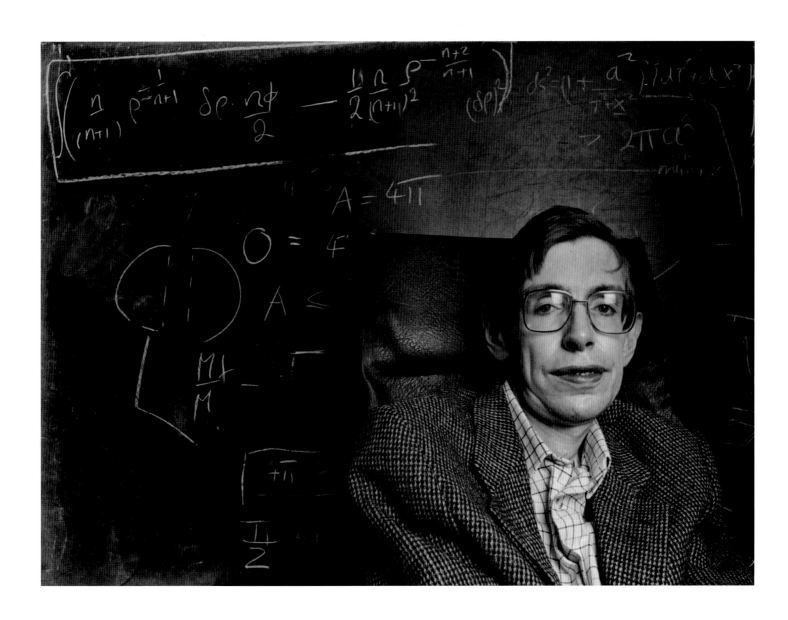

Stephen Hawking, physicist. Cambridge, England, June 15, 1988

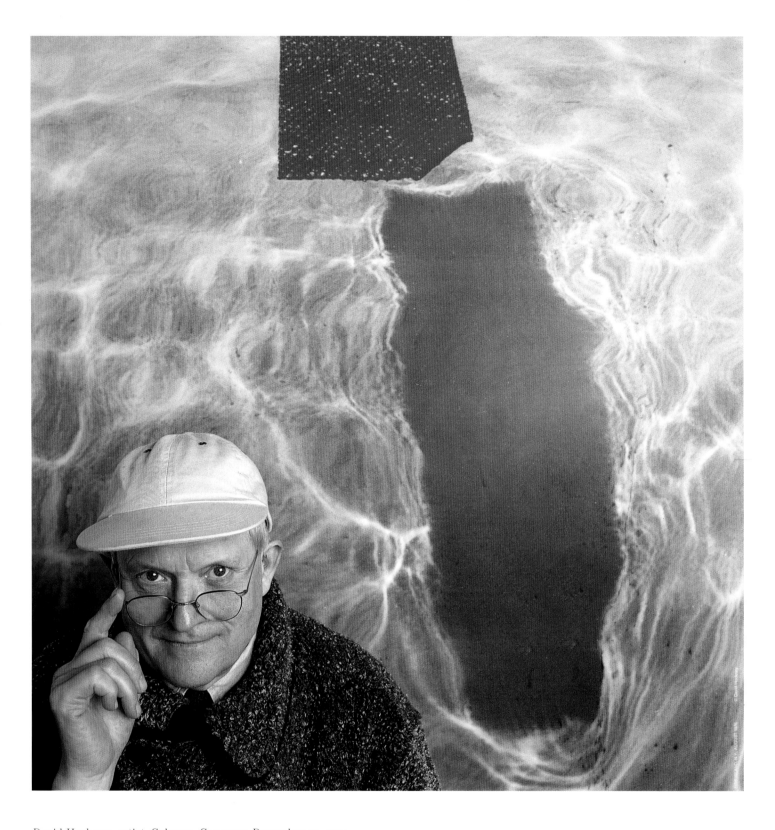

David Hockney, artist. Cologne, Germany, December 19, 1997

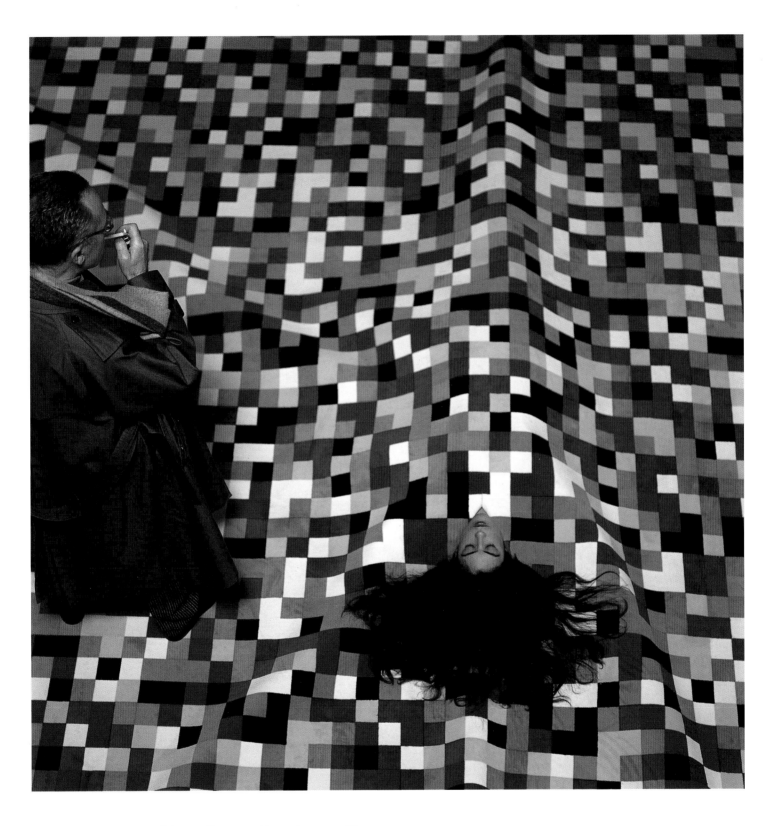

Gerhard Richter, artist. Cologne, Germany, November 25, 1988

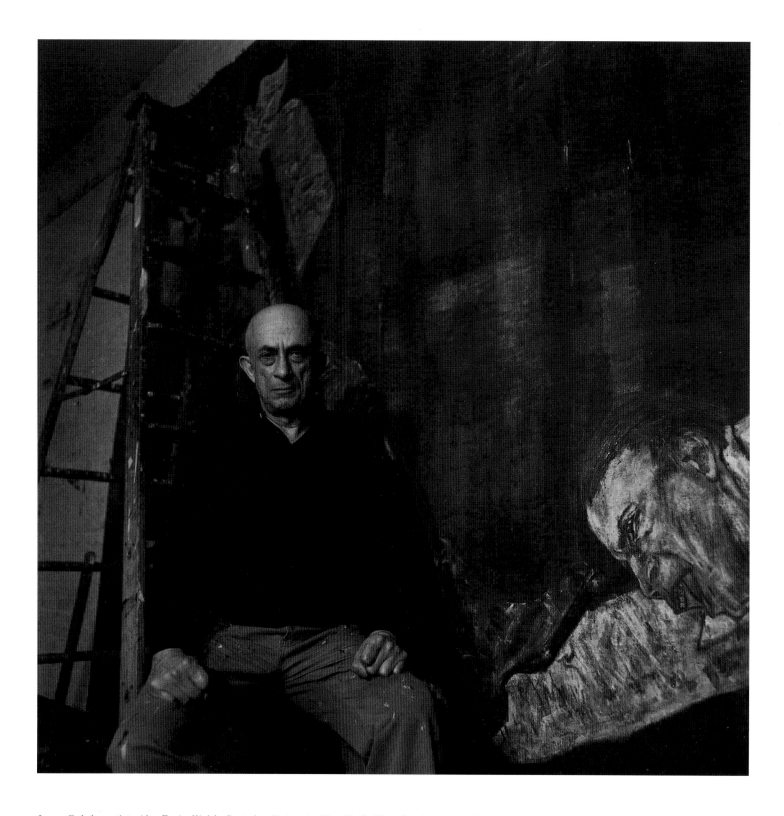

Leon Golub, artist. Abe Frajndlich's first day living in New York City, October 21, 1984

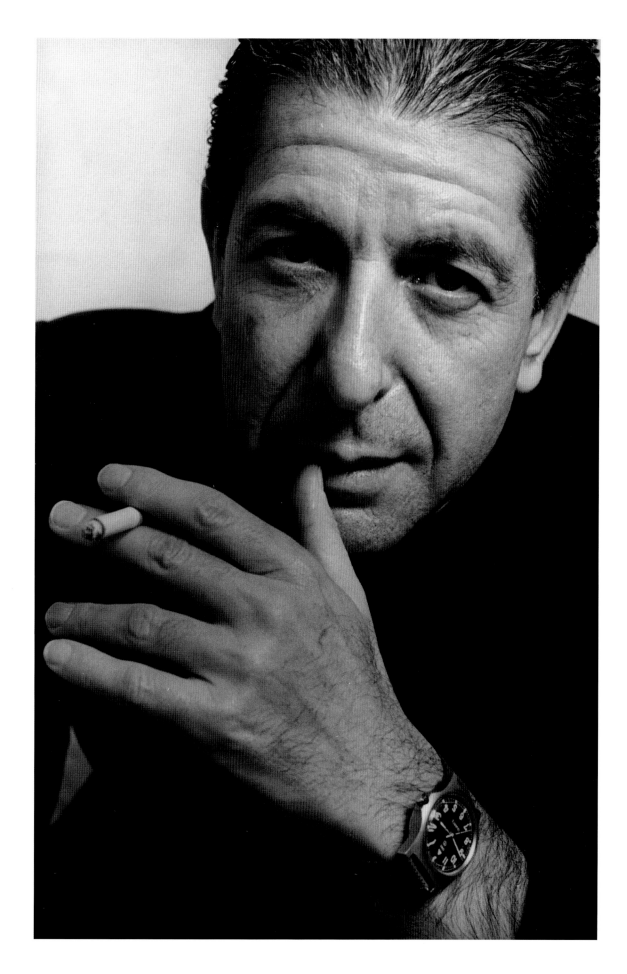

Leonard Cohen, singer and poet. New York City, May 6, 1985

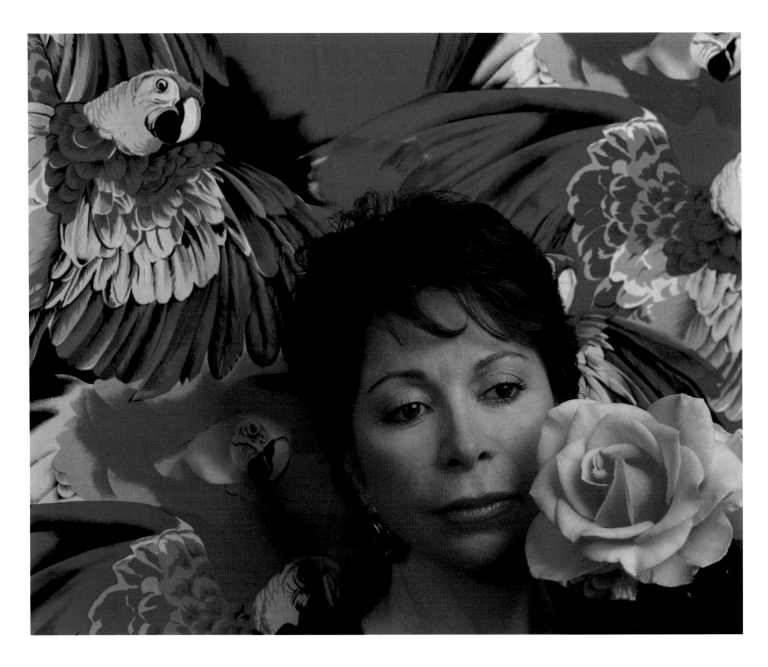

Isabel Allende, writer. San Rafael, California, August 23, 1993

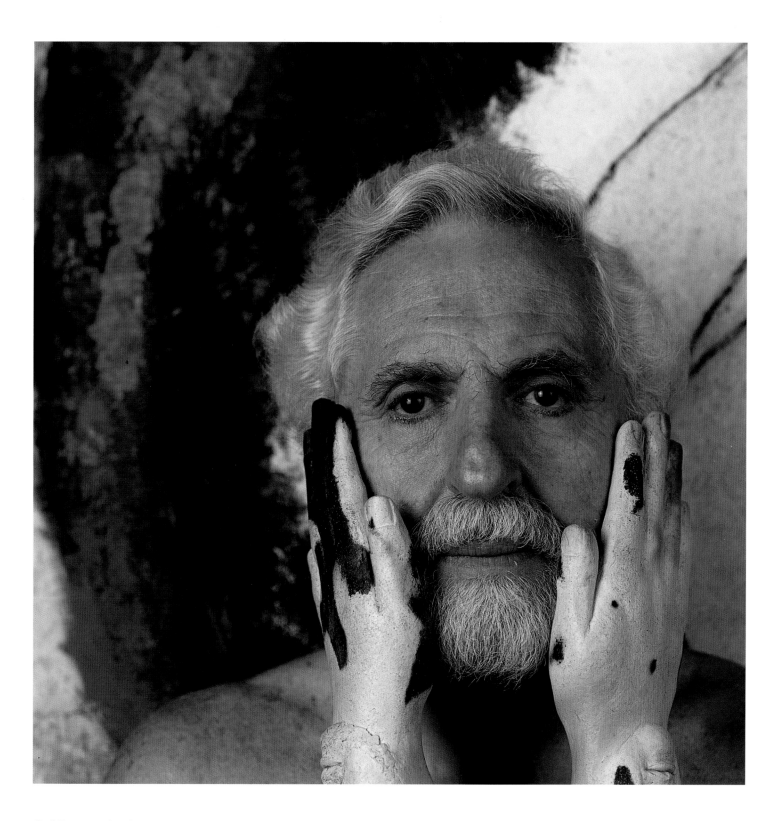

Carl Djerassi, biochemist and inventor of the birth control pill.
Santa Cruz, California, September 12, 1991

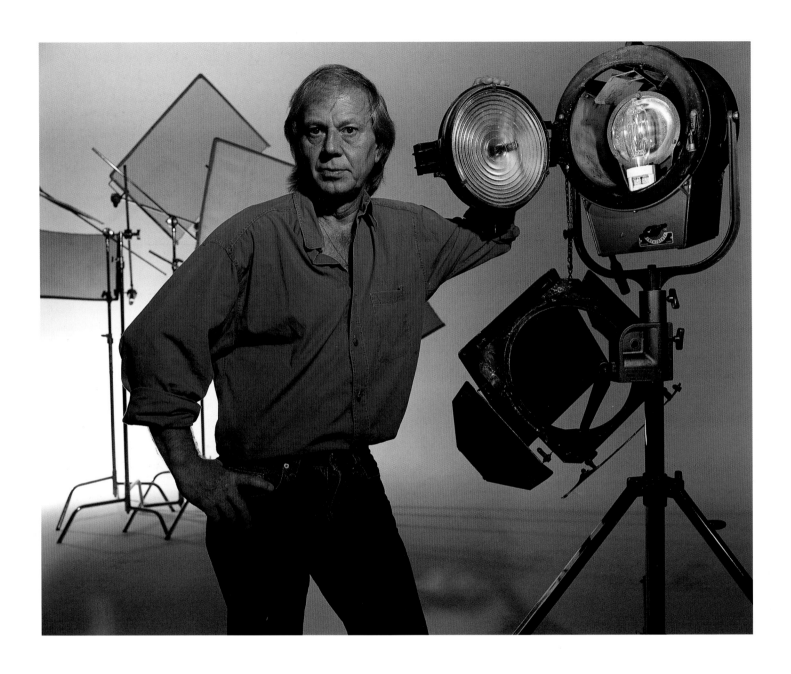

Wolfgang Peterson, director. Hollywood, August 11, 1993

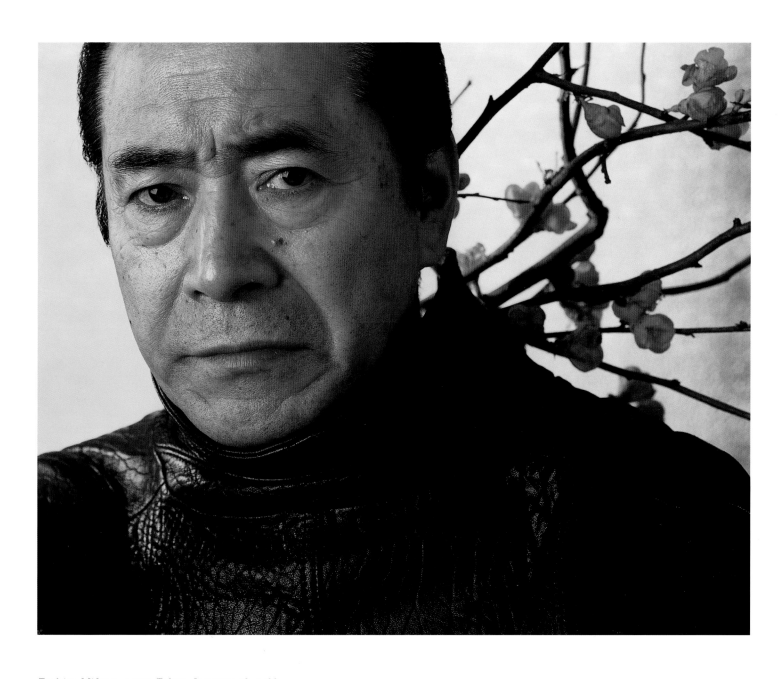

Toshiro Mifune, actor. Tokyo, January 18, 1988

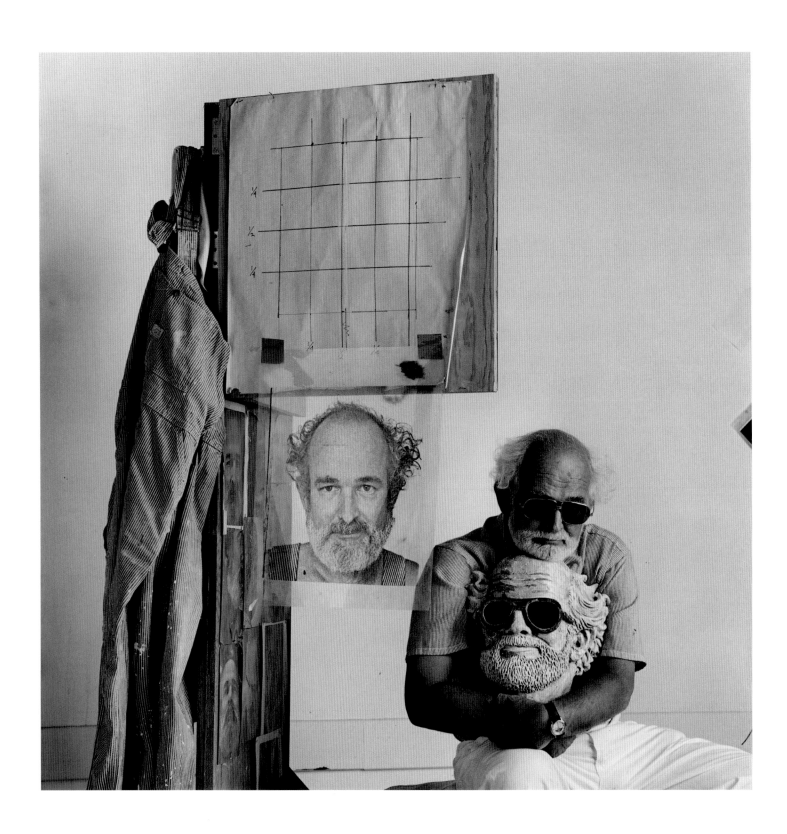

Robert Arneson, ceramic artist. Benicia, California, July 25, 1986

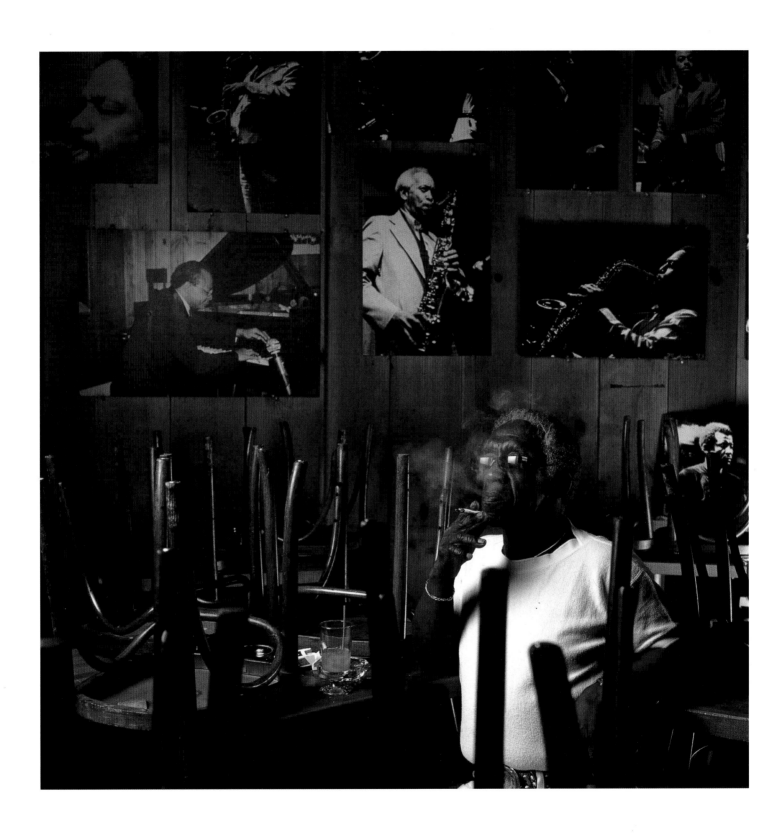

Art Blakey, jazz drummer. Sweet Basil's, New York City, April 20, 1986

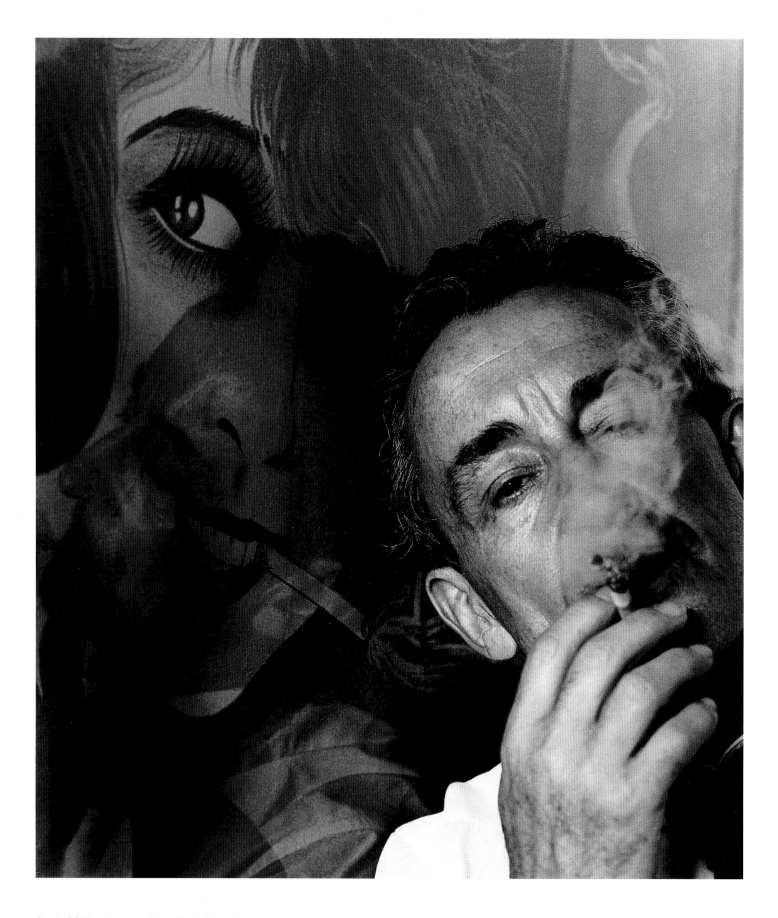

Louis Malle, director. New York City, September 15, 1987

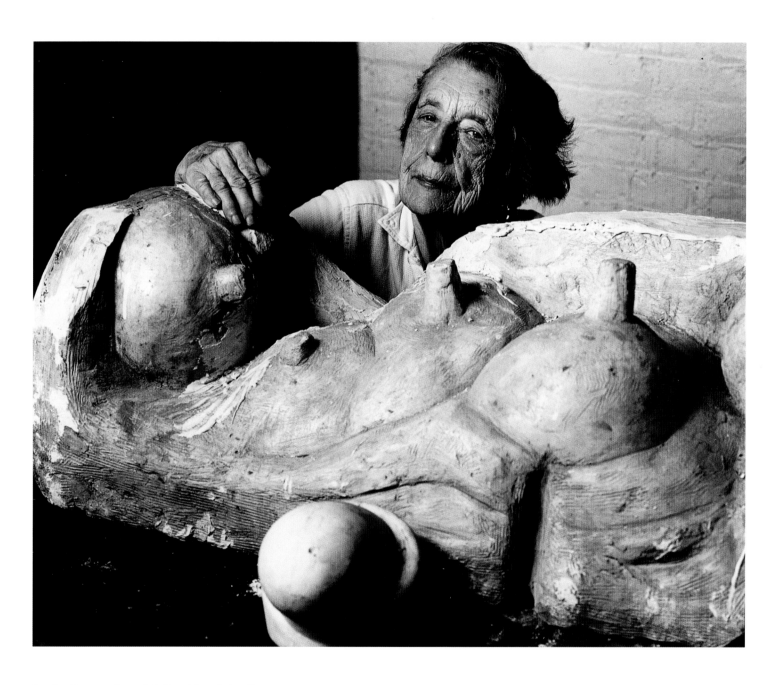

Louise Bourgeois, artist. Brooklyn, July 28, 1994

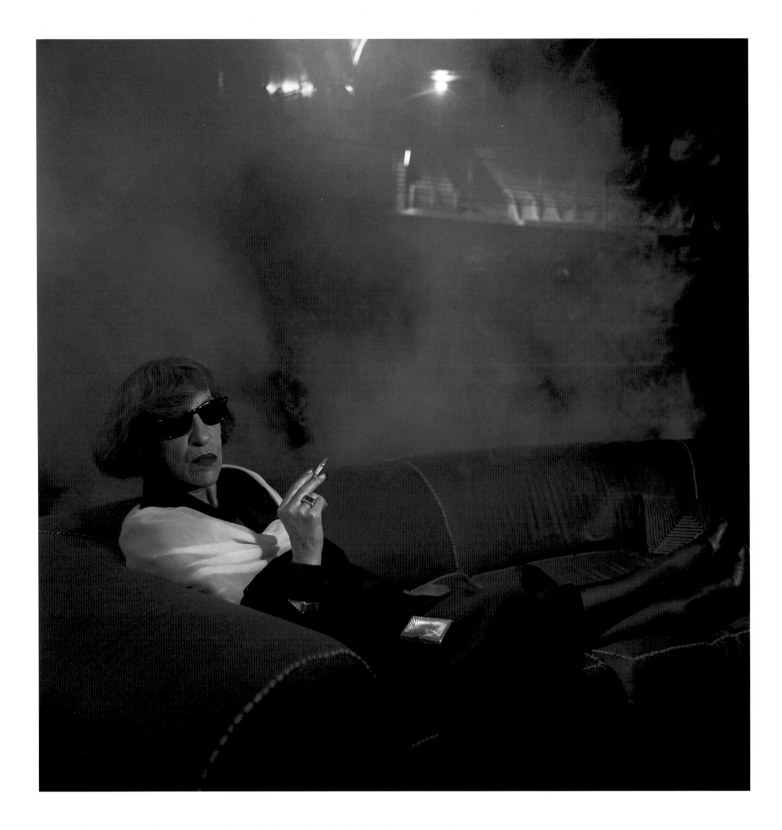

Andree Putman, interior designer. The Palladium, New York City, March 25, 1988

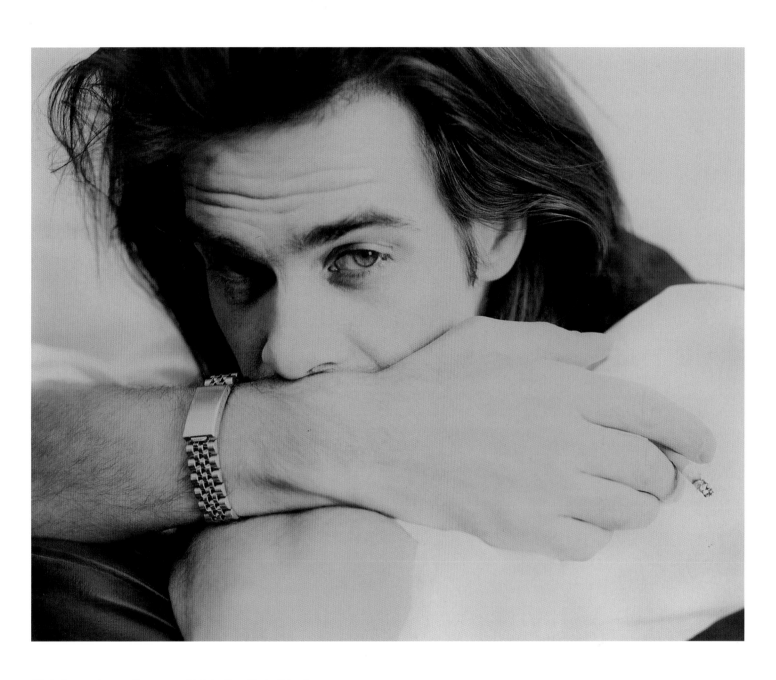

Nick Cave, singer. Gramercy Hotel, New York City, January 30, 1992

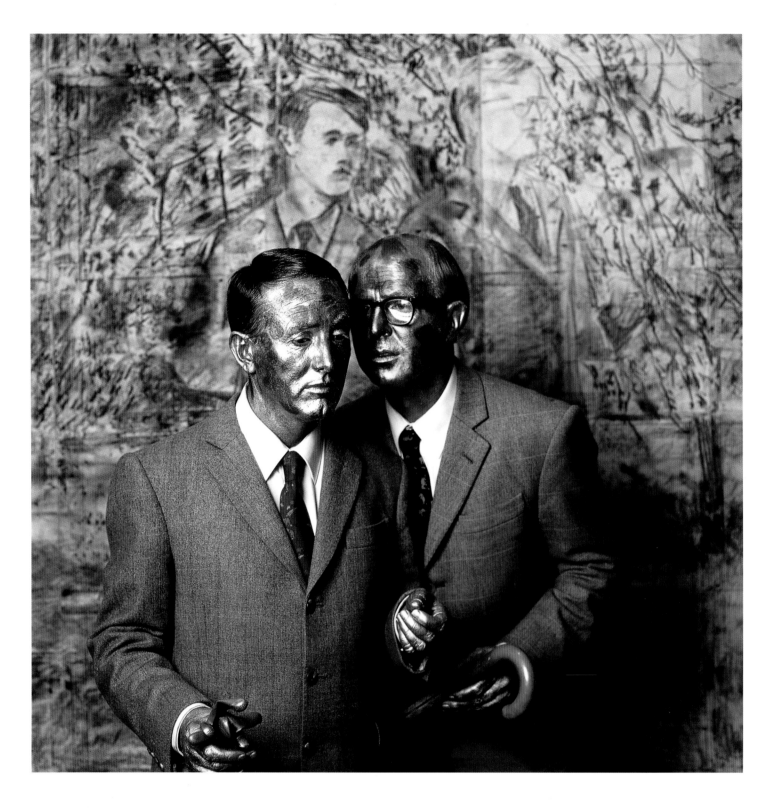

Gilbert & George, artists. New York City, September 25, 1991

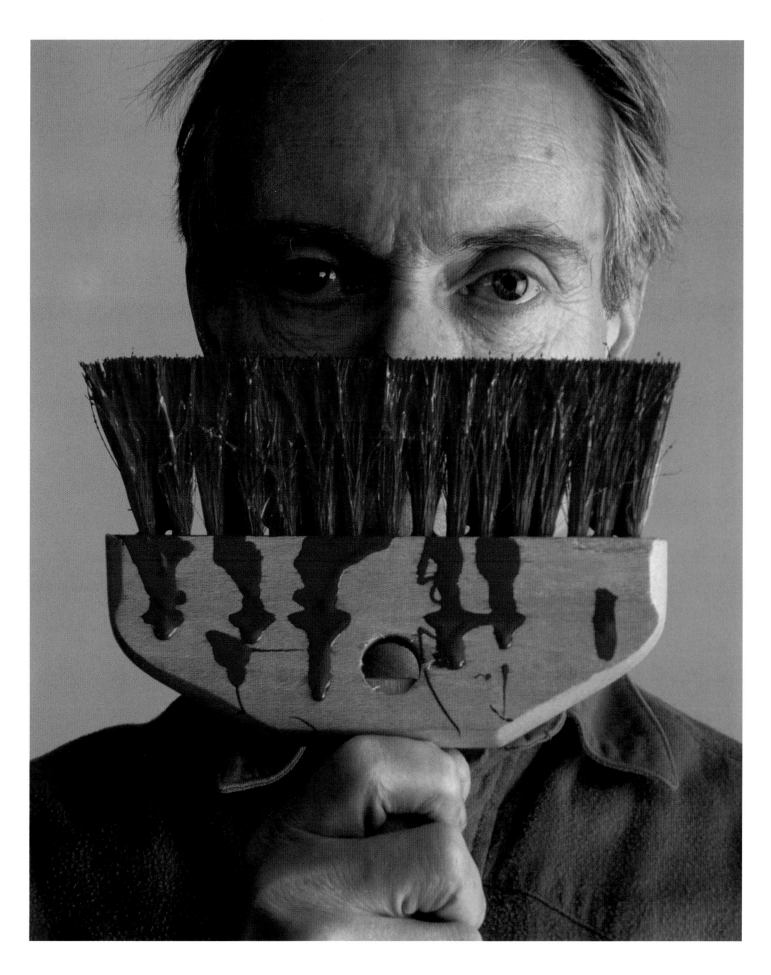

Roy Lichtenstein, artist. New York City, December 14, 1985

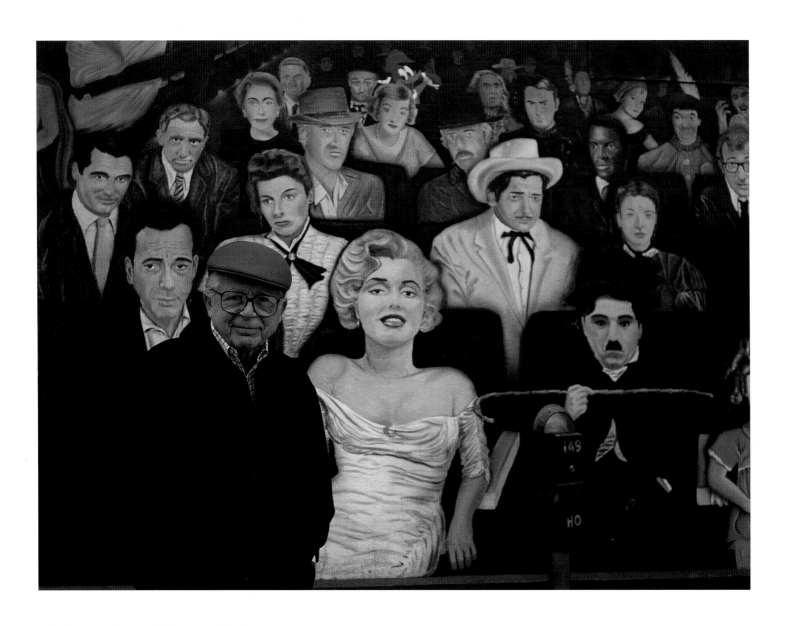

Billy Wilder, director. Hollywood, July 18, 1991

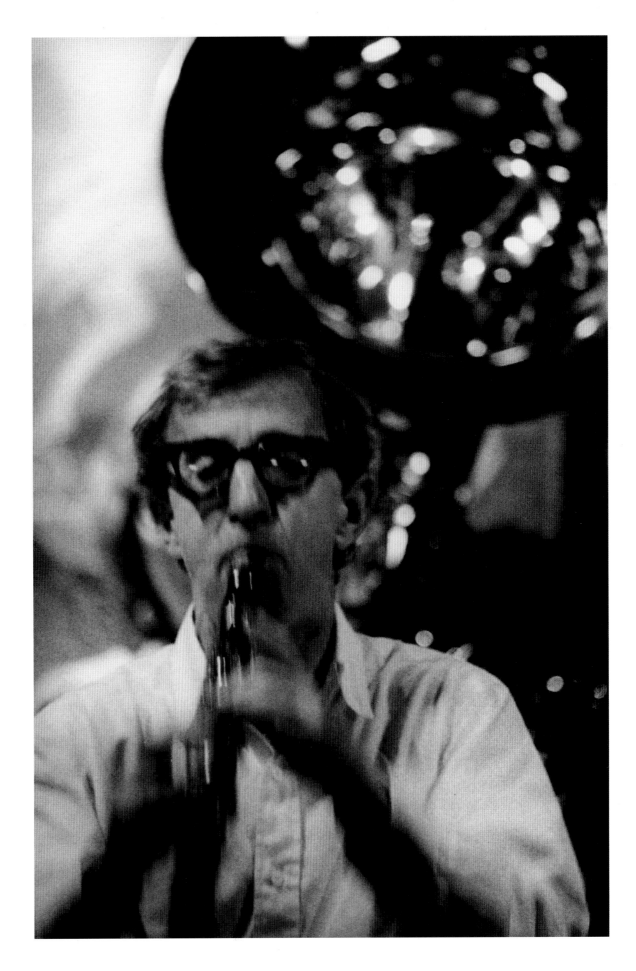

Woody Allen, director, actor and musician. Michael's Pub, New York City, January 16, 1995

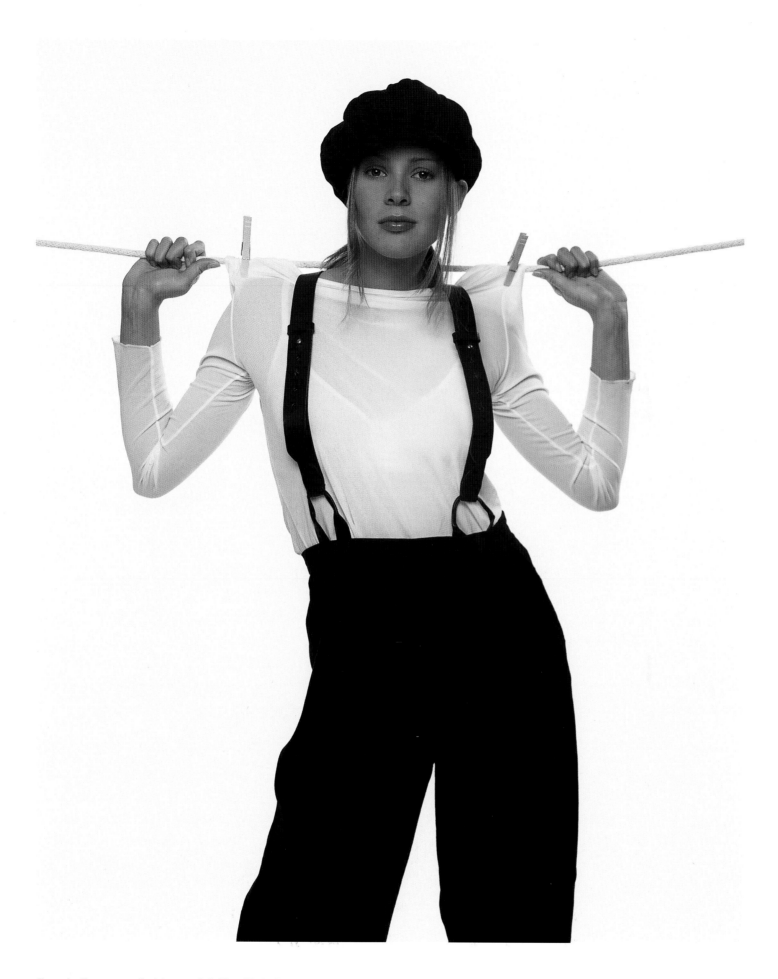

Georgia Goetmann, fashion model. New York City, December 5, 1994

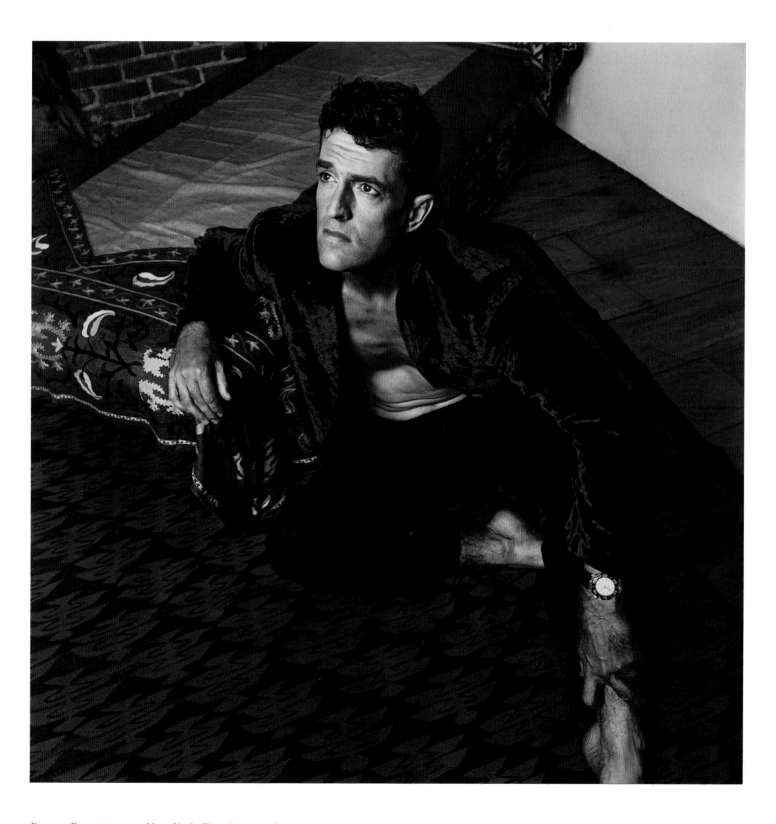

Rupert Everett, actor. New York City, August 18, 1997

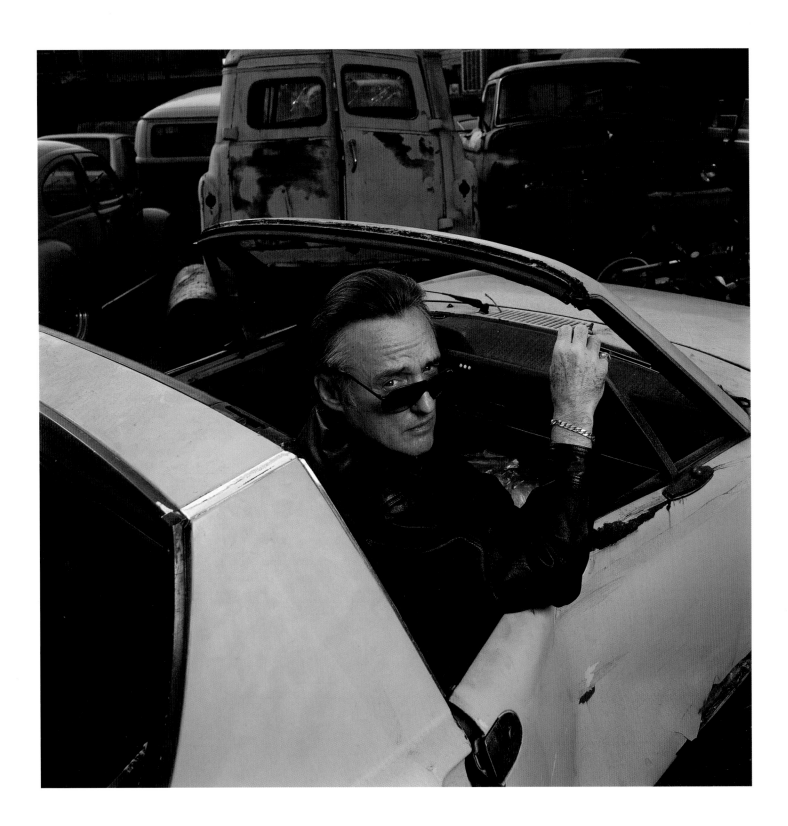

Dennis Hopper, director, actor and photographer. Venice, California, October 14, 1988

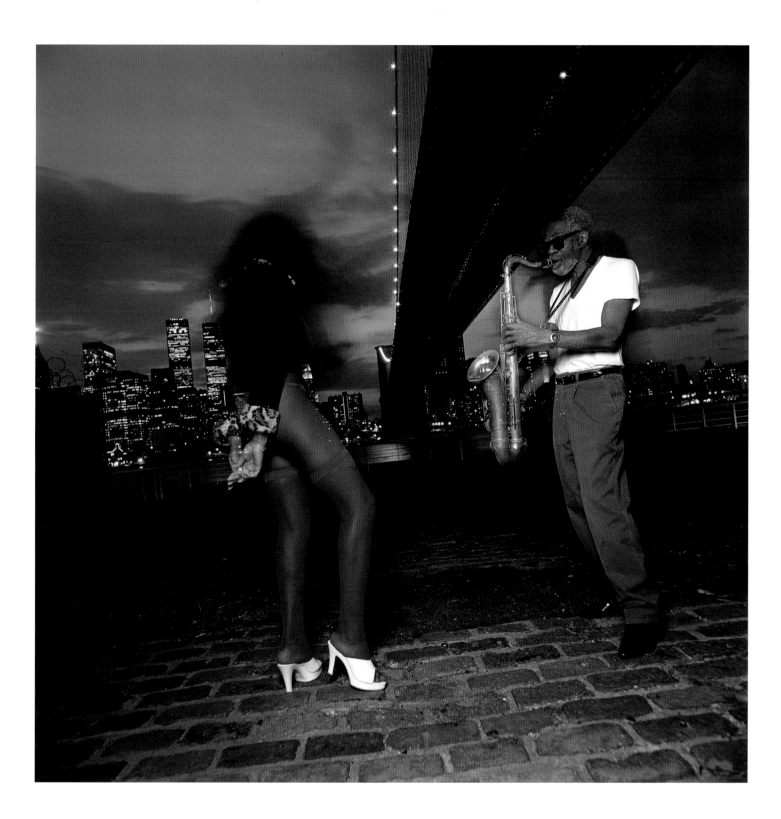

Joe Henderson, jazz saxophonist. Brooklyn, August 18, 1995

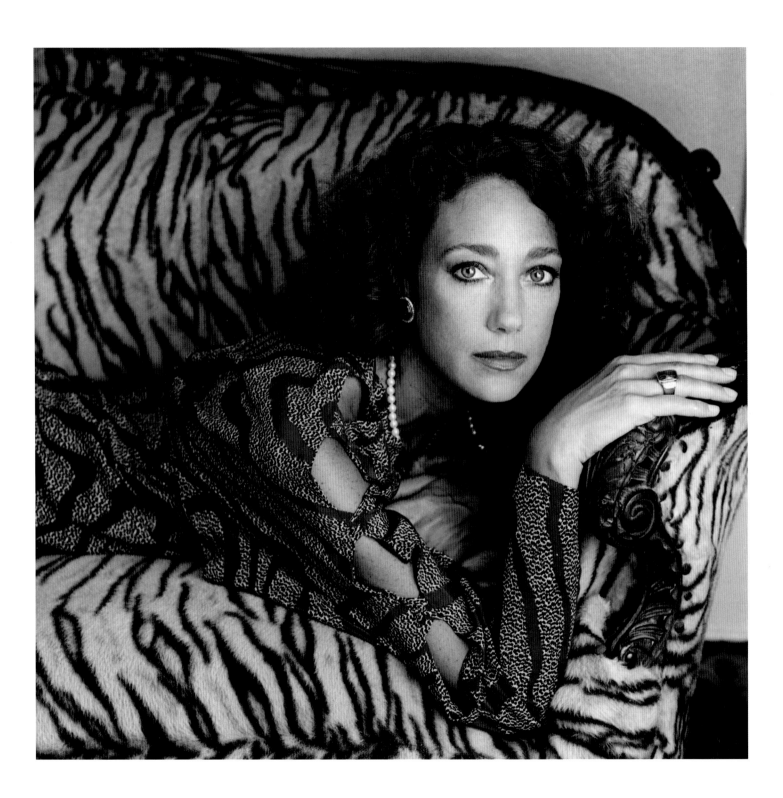

Marisa Berenson, actress. Hemingway's House, Key West, Florida, August 15, 1987

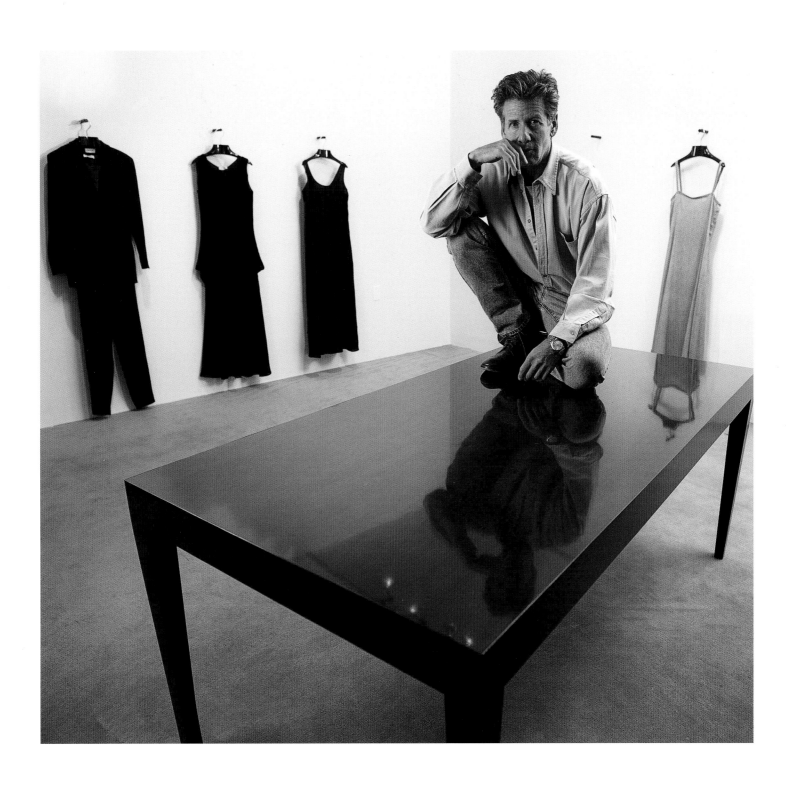

Calvin Klein, fashion designer. New York City, January 24, 1994

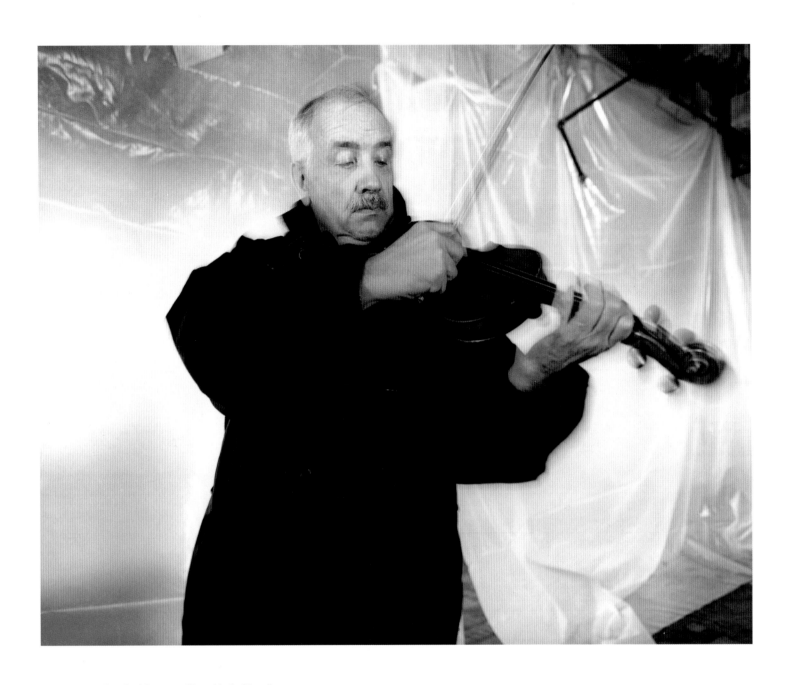

Armin Mueller-Stahl, actor. New York City, January 13, 1994

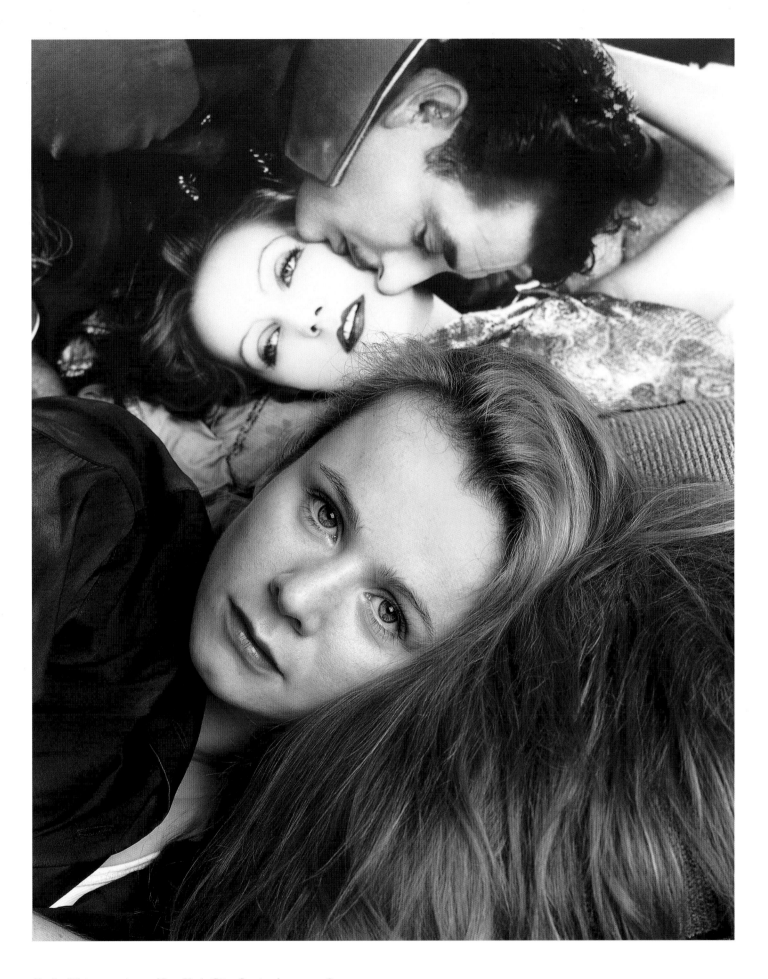

Emily Watson, actress. New York City, September 2, 1998

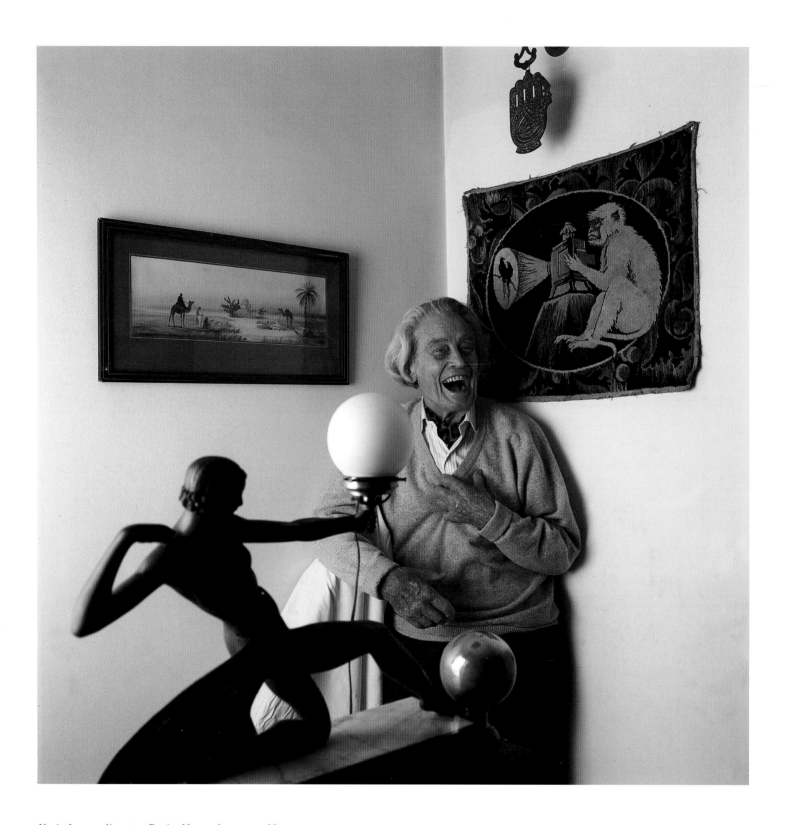

Yoris Ivans, director. Paris, November 22, 1988

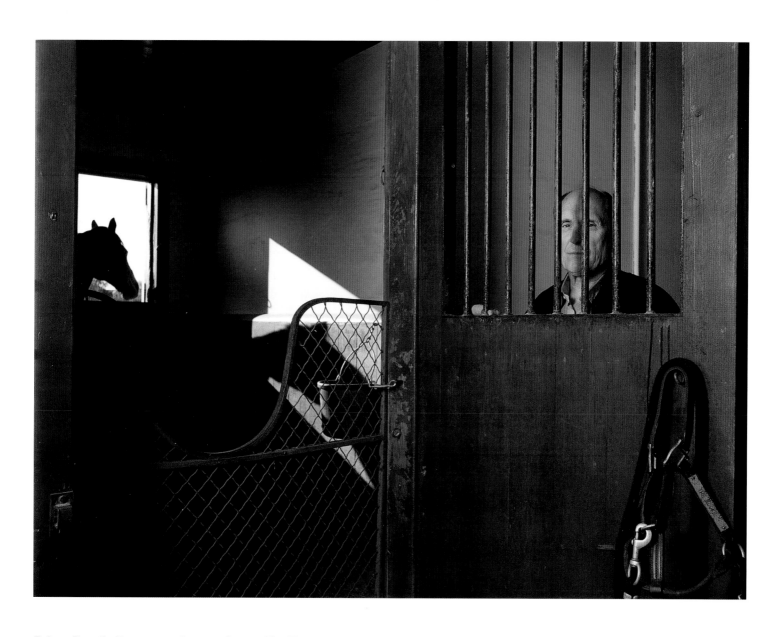

Robert Duvall, director, producer and actor. The Plains, Virginia, May 5, 1998

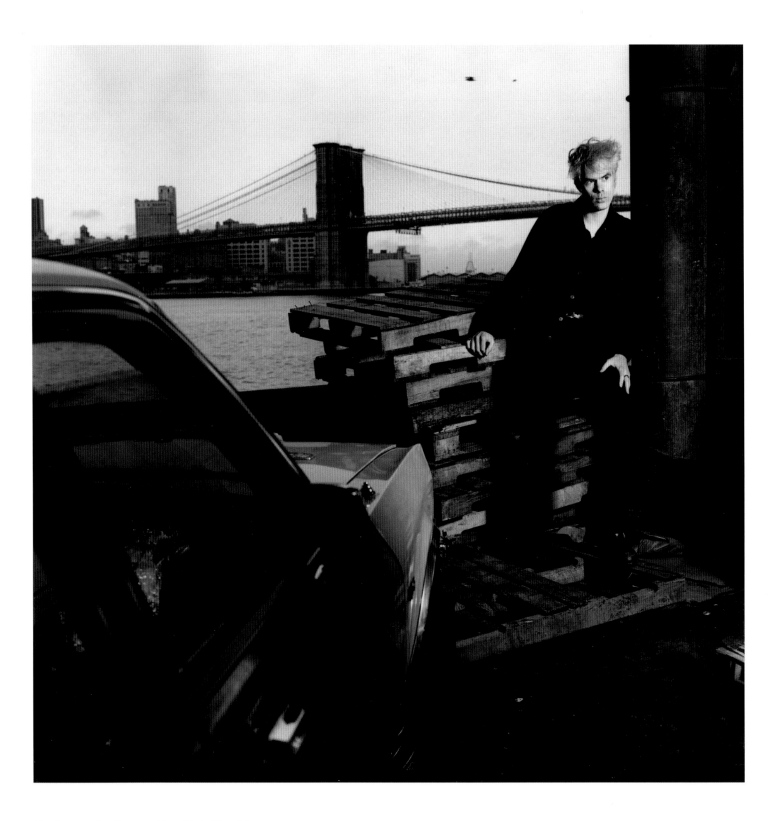

Jim Jarmusch, director. New York City, May 15, 1992

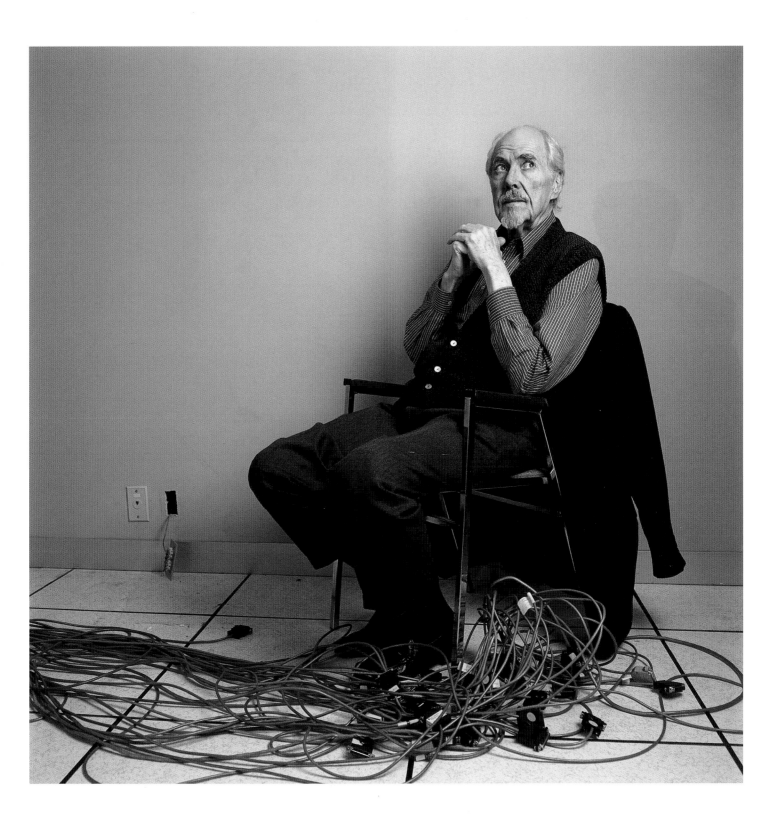

Robert Altman, director. Kansas City, Missouri, July 17, 1994

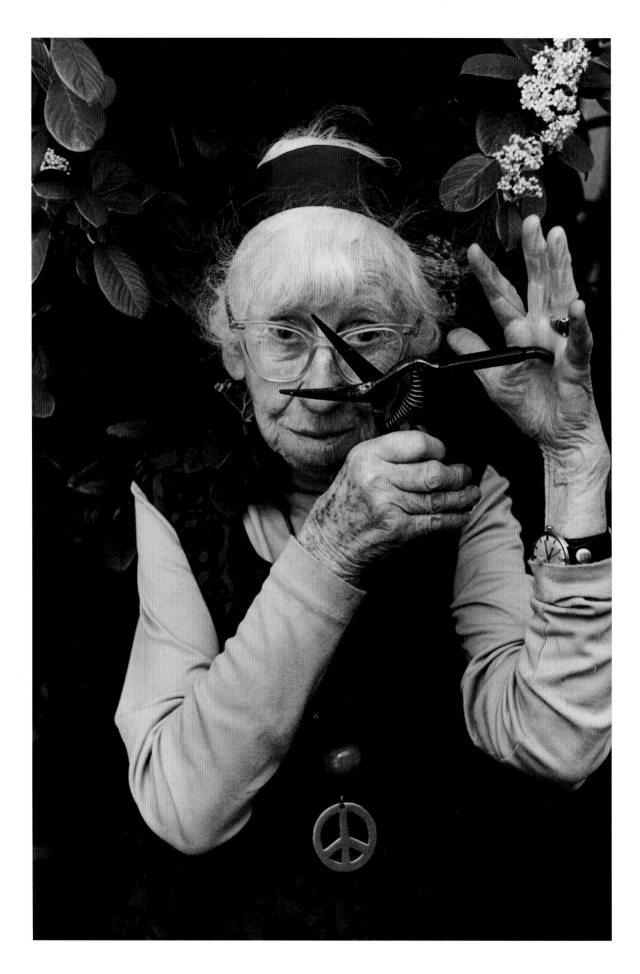

Imogen Cunningham, photographer. San Francisco, July 9, 1975

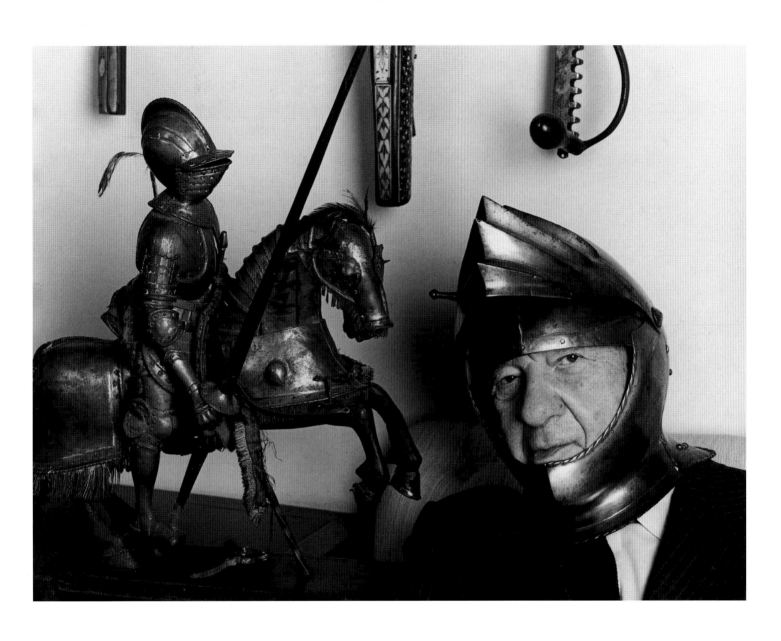

Charles Addams, cartoonist. New York City, April 21, 1988

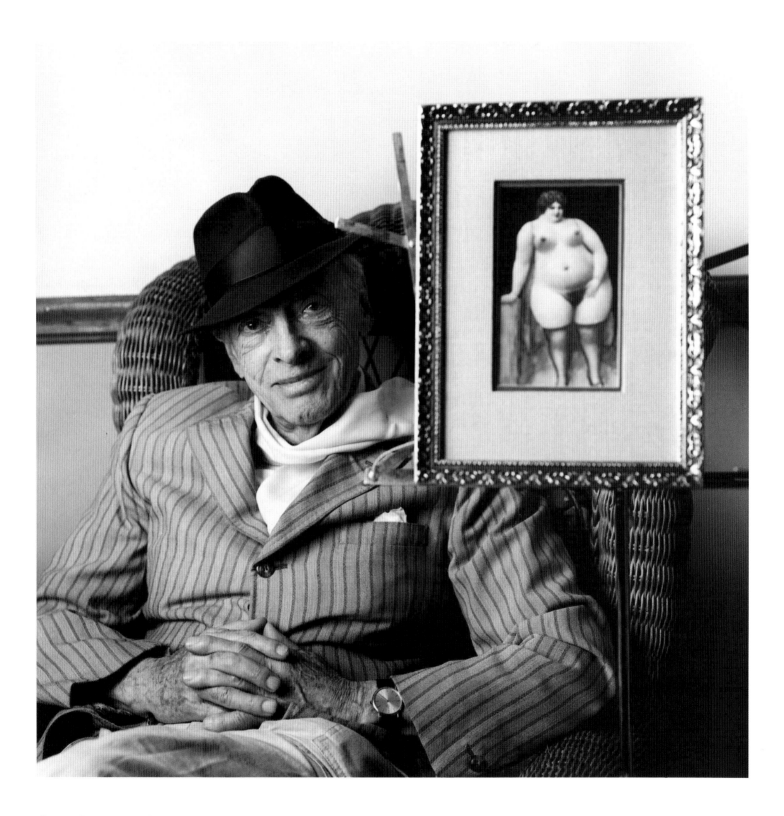

Saul Bellows, writer. Brattleboro, Vermont, May 14, 1994

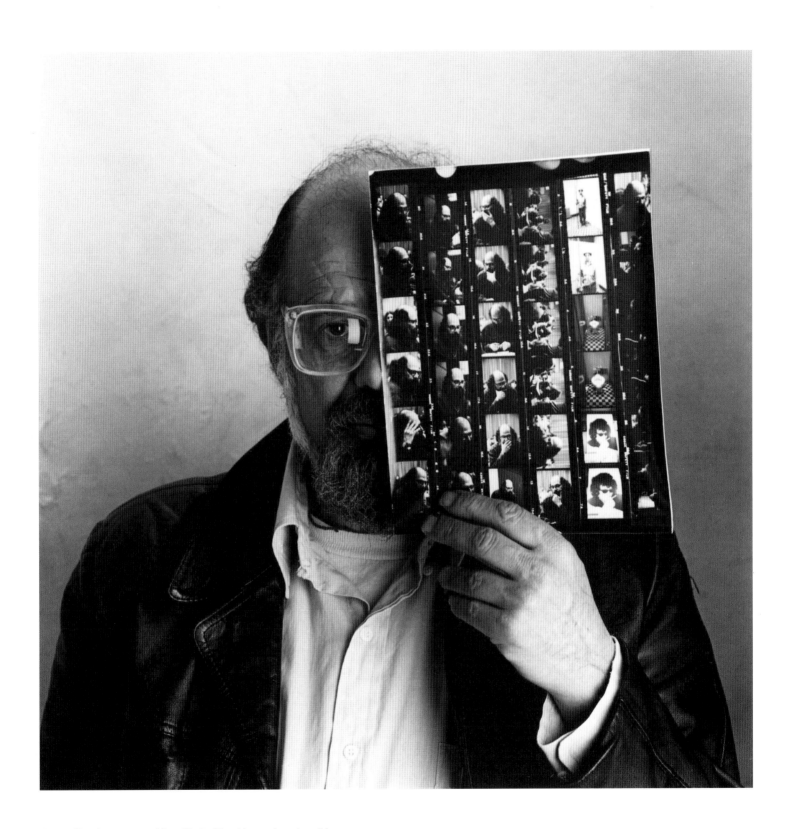

Allen Ginsberg, poet. New York City, November 6, 1986

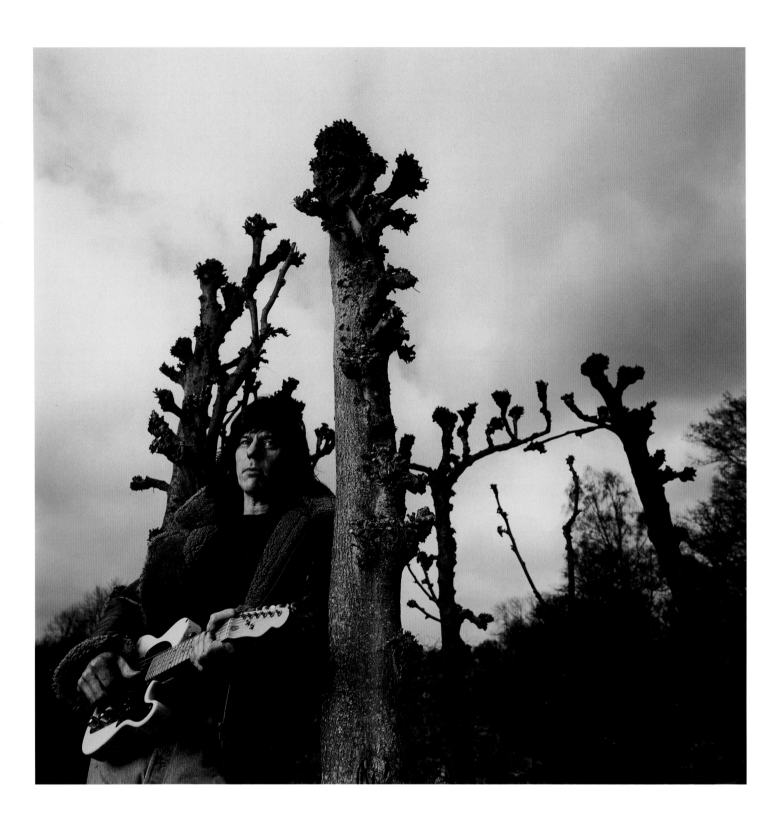

Jeff Beck, guitarist. Kent, England, April 16, 1993

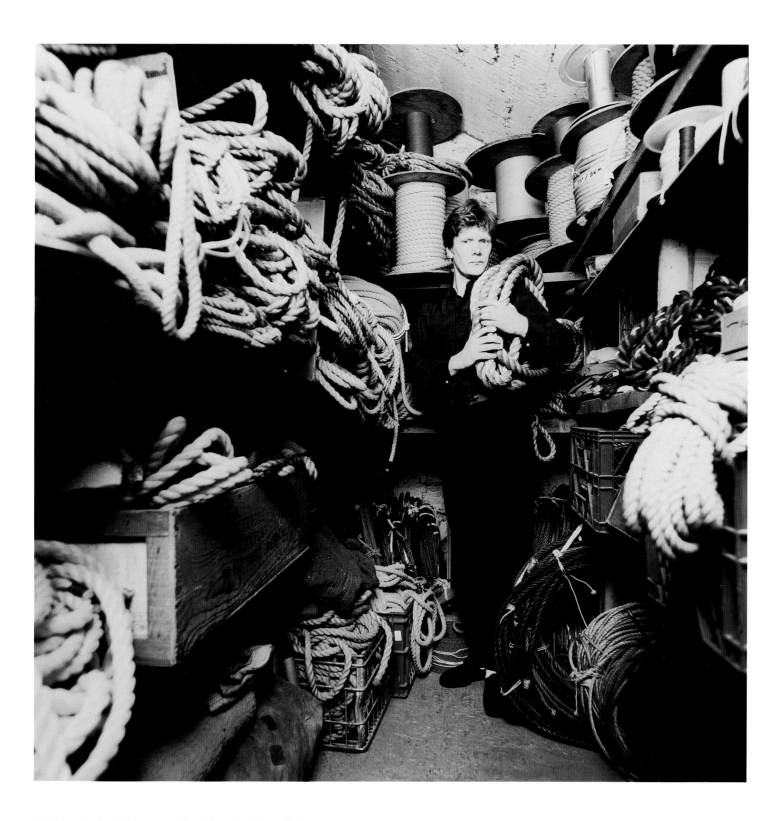

Philippe Petit, tightrope walker. New York City, July 27, 1992

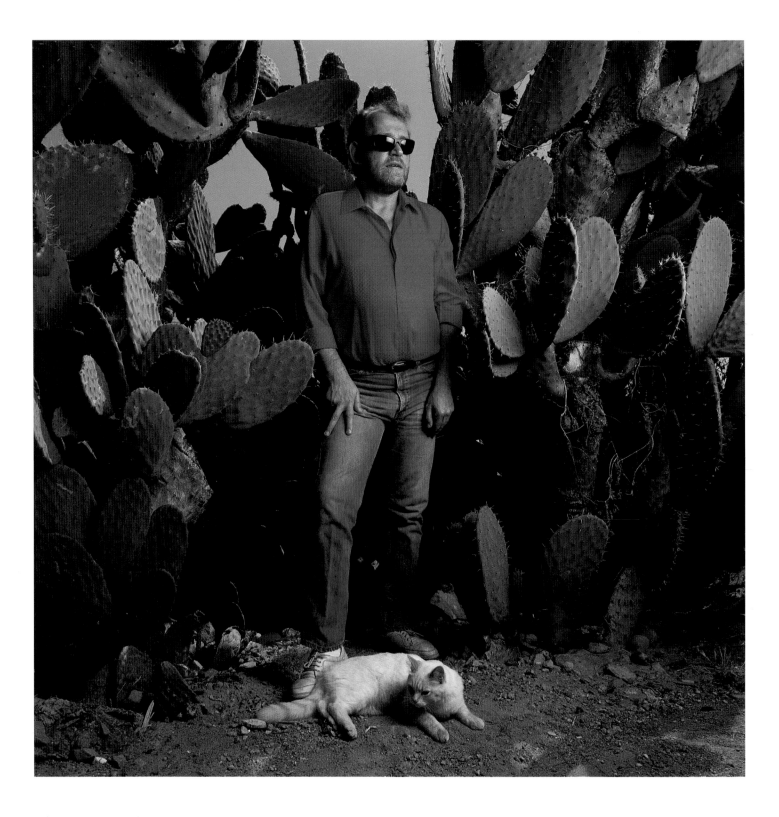

Joe Cocker, rocker. Santa Barbara, California, June 14, 1986

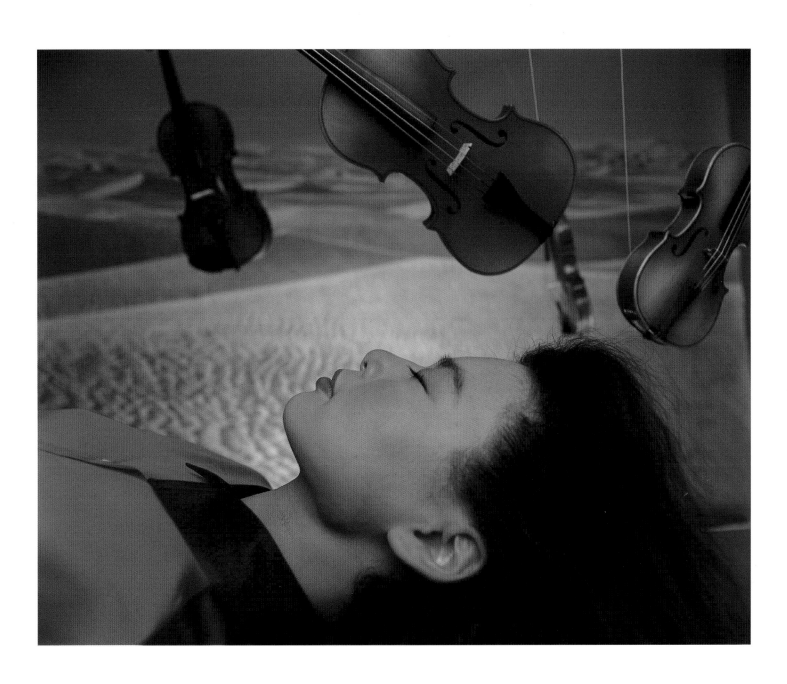

Midori, violinist. New York City, November 25, 1991

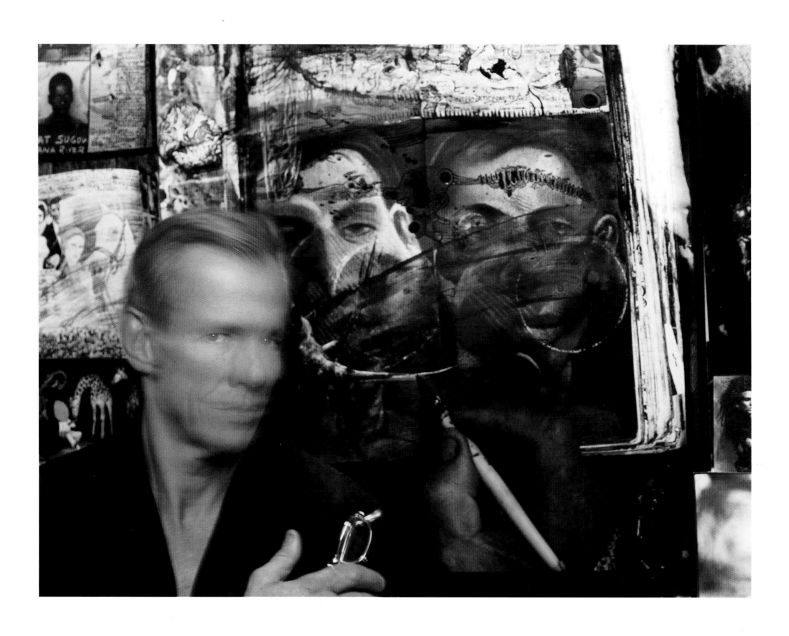

Peter Beard, photographer. New York City, April 30, 1997

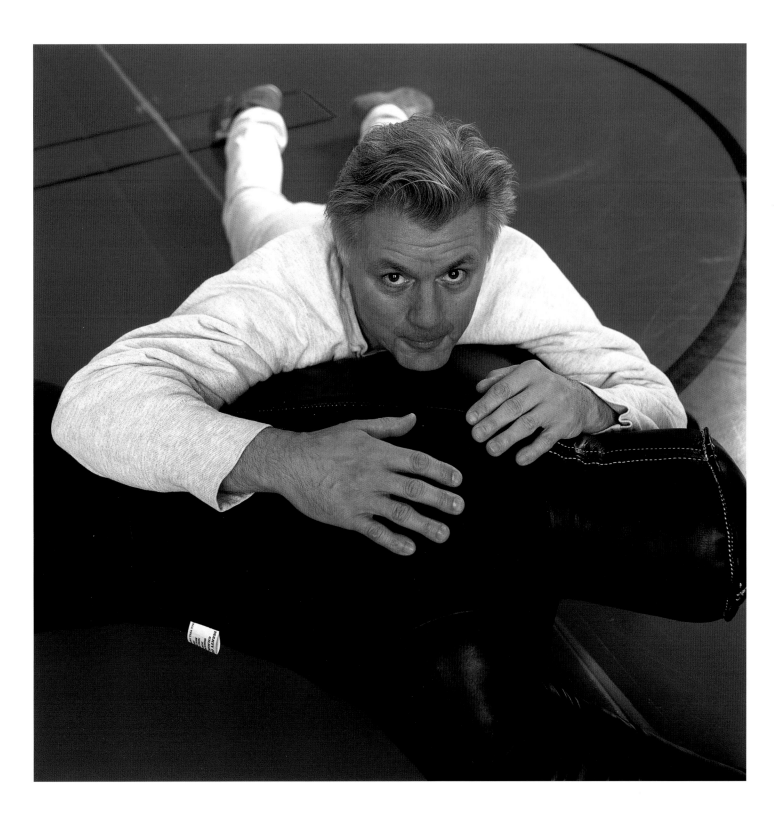

John Irving, writer. Manchester, Vermont, March 27, 1998

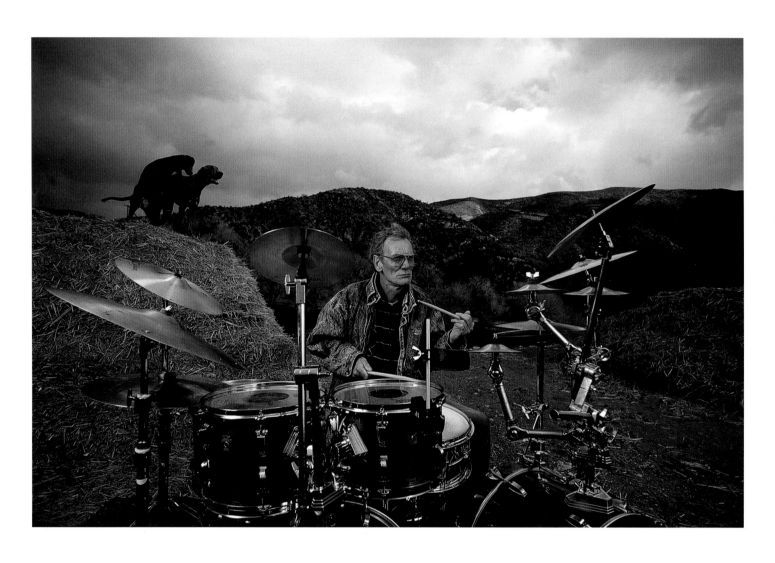

Ginger Baker, drummer. Los Angeles County, February 15, 1990

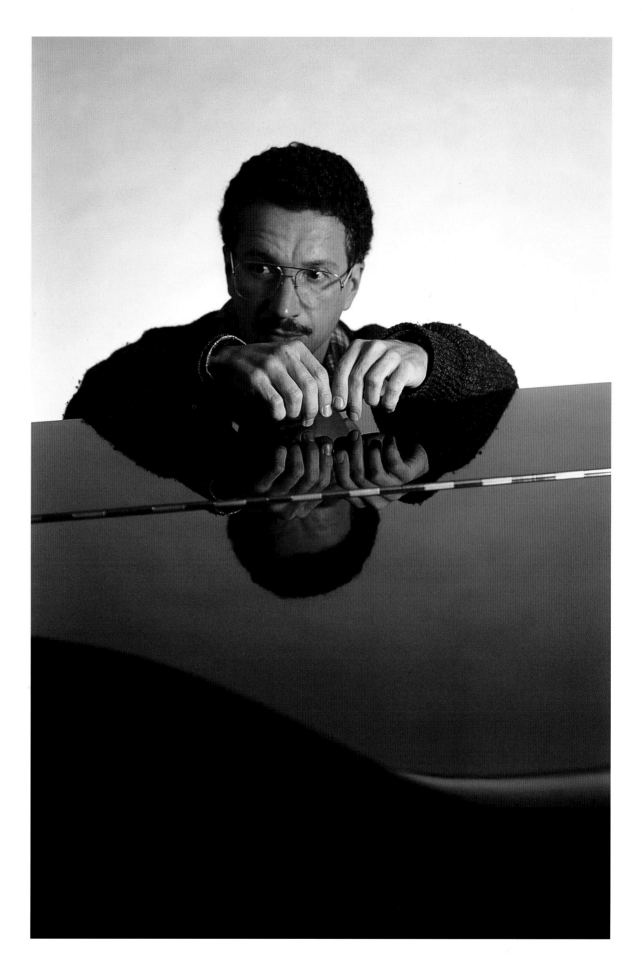

Keith Jarrett, jazz pianist. Delaware Water Gap, Pennsylvania, December 8, 1987

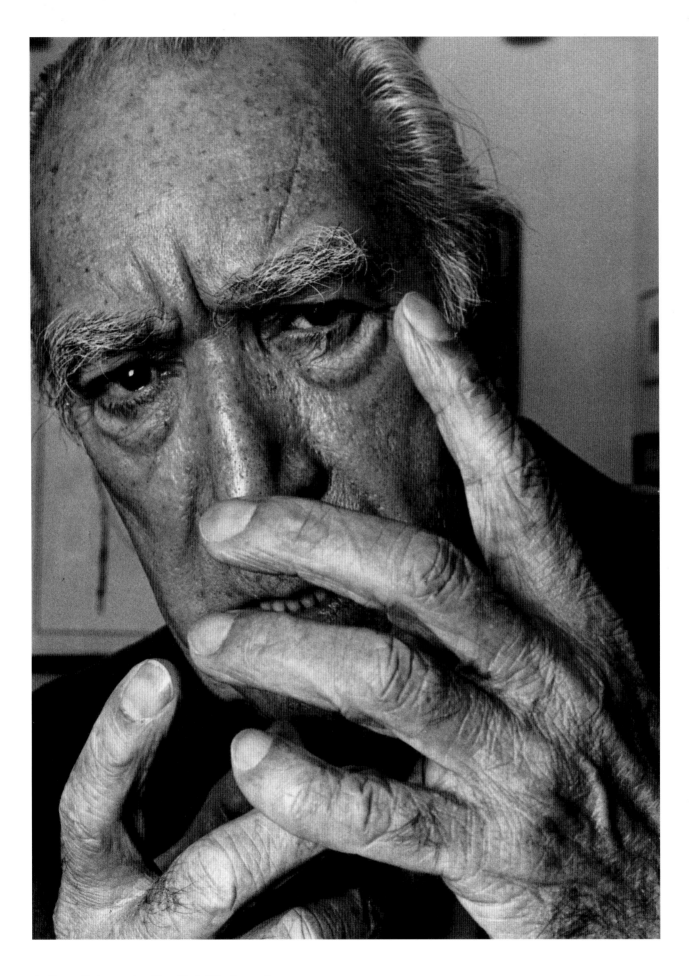

Anthony Quinn, actor. New York City, June 28, 1995

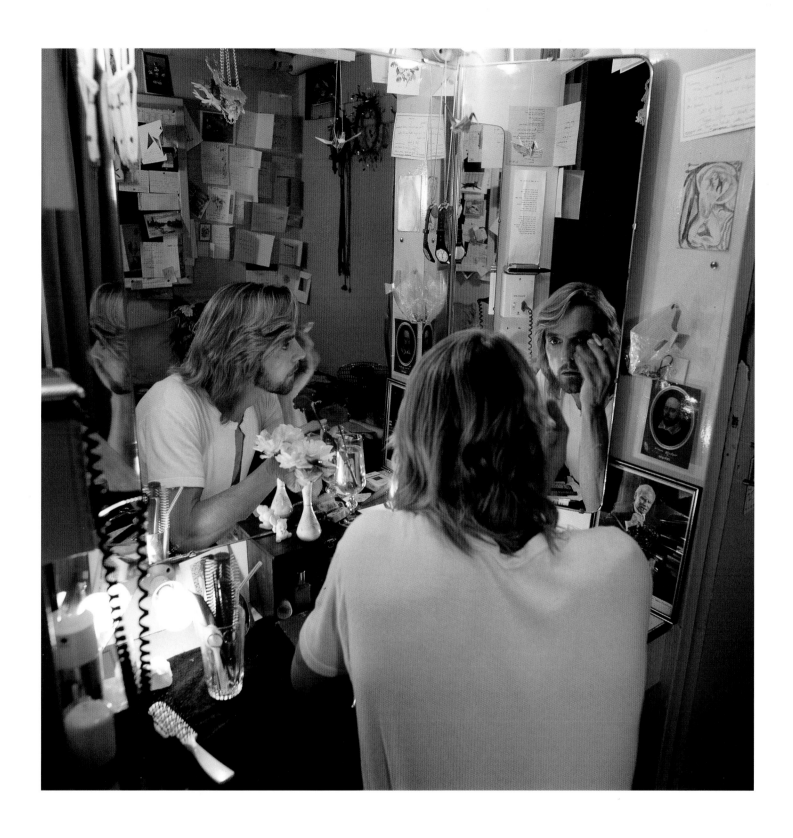

Jeremy Irons, actor. Stratford-on-Avon, England, September 23, 1986

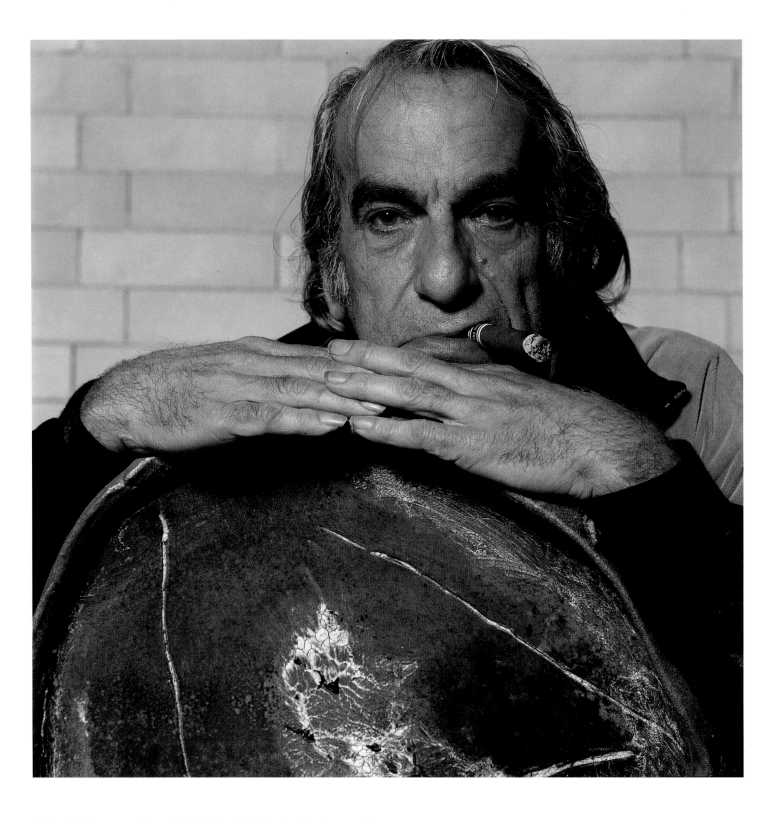

Peter Voulkos, ceramic artist. Berkeley, California, March 15, 1986

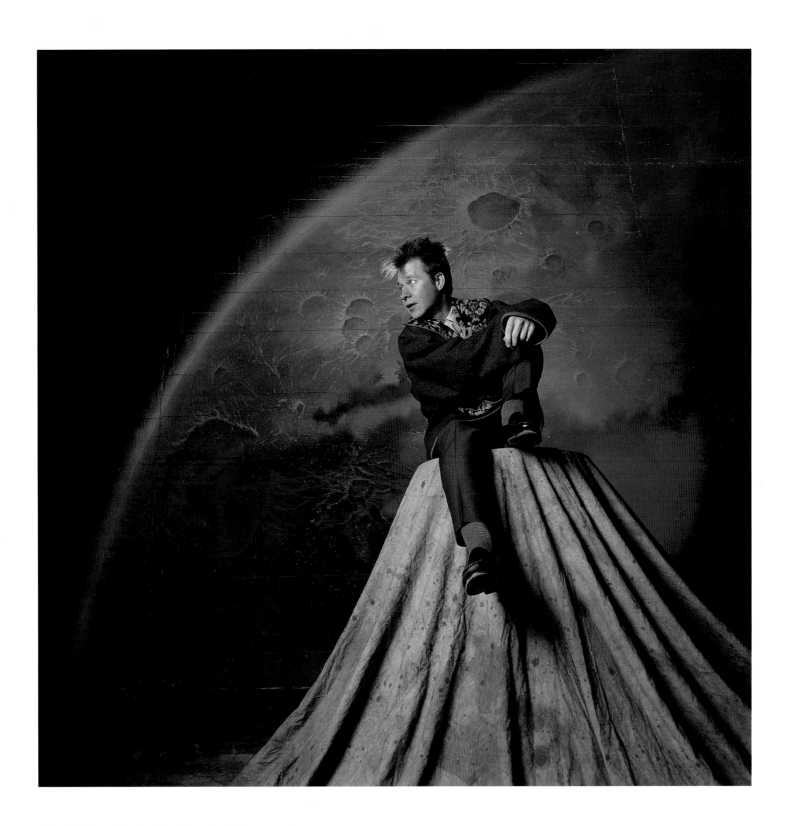

Peter Sellars, director. Los Angeles, February 16, 1990

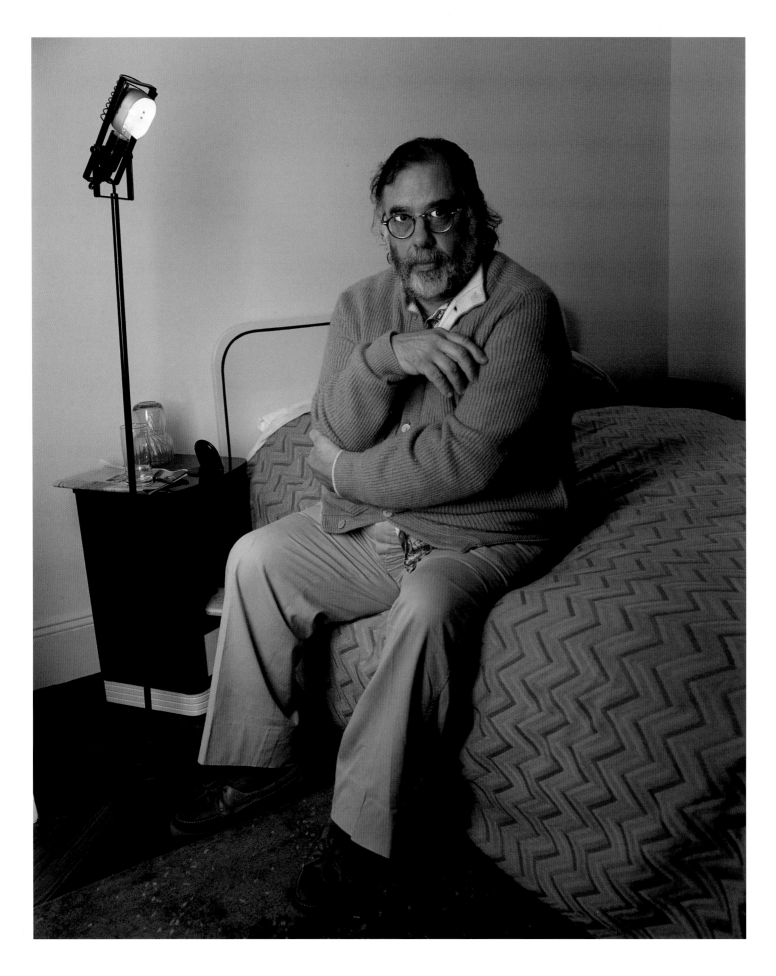

Francis Ford Coppola, director. New York City, October 20, 1994

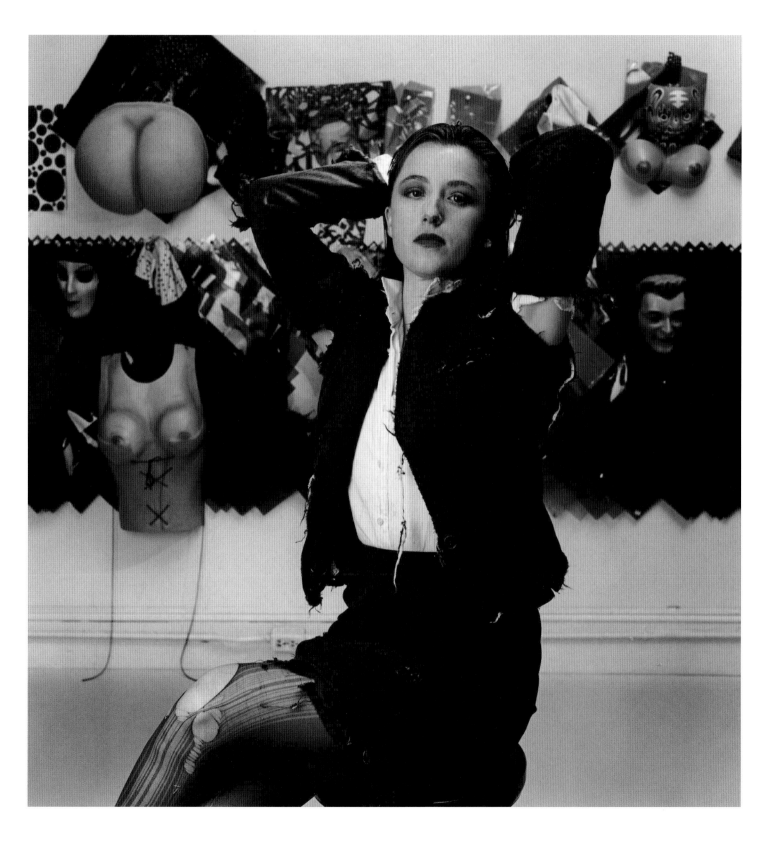

Cindy Sherman, artist. New York City, March 27, 1987

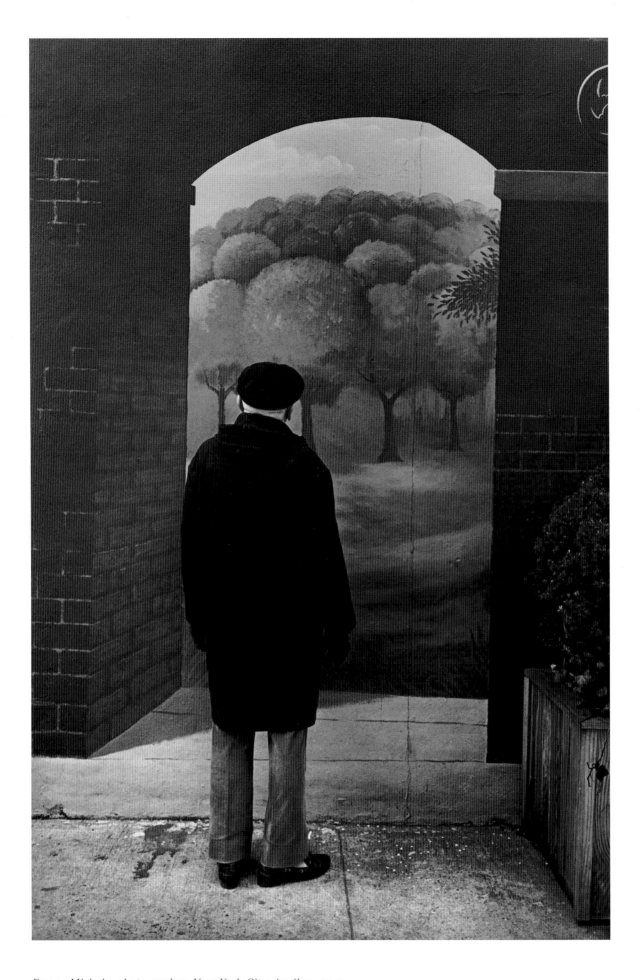

Duane Michals, photographer. New York City, April 12, 2000

Afterword
Abe Frajndlich

*Gravity and Time are like grand thieves, the bad guys
who always win.
Photography, playing a walk-on role, temporarily apprehends
the culprits.*

I see photography as an "entropic freeze." I have even used
this as the title of one of my portfolios. Everything in the uni-
verse is moving towards a state of degeneration and chaos or
entropy. But a photographic portrait suddenly stops, or freezes
a person in his/her time-space trajectory. Since I meet most of
my subjects only once, my objective is to make the most of our
brief, but precious, encounter. My sitters may engage me in
conversation, or graciously invite me to a cup of coffee or din-
ner. If the photo session is fruitful, a portrait emerges that
reveals a facet of their complex inner domain.

When I first began taking photos, in 1970, portraiture was
an integral part of my artistic exploration. While developing
my craft, I took many photos of children. Two of my first book
projects were extended portraits of people whom I knew well:
the performer Rosebud Conway in *Figments* (1975) and the pho-
tographer and writer Minor White in *Lives I've Never Lived*
(1983). I lived and worked with each of them for three years.

When I moved to New York in 1984, I began working for
various magazines. Significantly, these portraits were almost
always of strangers, not of people with whom I had already
developed a high level of trust. Instead, trust had to be estab-
lished upon first meeting. Eighty five percent of my job involved
psychology, ten percent luck, and, maybe, the last five percent
photography. While shooting portraits, I continued to explore
other themes, including still lifes, abstract compositions,
nudes, landscapes, and street scenes.

Shortly after my arrival in New York, I met Hans-Georg
Pospischil, the art director at the *FAZ Magazin*. After looking
at my work, Pospischil invited me to go on an assignment to
San Pedro, California to photograph the writer Charles Bukow-
ski (1920–1994). For over six years the magazine had wanted
to publish a story on him but had been unsuccessful. I was
familiar with Bukowski's work and his reputation. It was ru-
mored that he had thrown more than one photographer out of a
two-story window in a drunken brawl. After numerous phone
calls, a date for the shoot was set.

Up until that time I had had little magazine experience.
I arrived in California with only my cameras and color and
black-and-white film. With these tools along, I planned to cap-
ture the story behind the sixty-four-year-old writer who enjoyed
a cult following in Europe. I spent two days driving around
with Bukowski in his BMW and hanging out with him and girl-
friend Linda (who later became Mrs. Bukowski) in his home
and backyard, together with his ubiquitous beer bottles and old
typewriter. Pleased with my experience and results, I sent the

photos to Pospischil, but he gave me no indication of what he
thought. He simply said that we should talk when he was back
in New York. Two weeks later he called and asked to meet me
at the Algonquin Hotel for breakfast. When I arrived, he took
my folder with the photos, threw them onto the ground and
said, "Scheisse! Shit! Go do it again!"

What had I done wrong? Bukowski had been very open and had
spent a lot of time with me and I thought we had made some
revealing photos. Pospischil then pulled out some previous
issues of the magazine, explaining that "anyone can travel
across the country and bring back information about a sixty-
four-year-old man in his backyard. This is not your job. We
need you to go and return with images about the mythos that
surrounds that person. Your job is to make images that define
your subject ten years before and ten years after your encoun-
ter with him. With most of the people you will photograph, you
will have only one time in your life to bring back that mythos
for your audience." He continued: "Most people look at photo-
graphs in a magazine for about a quarter of a second. It is your
job to get them to stop and look for a half a second. Then you
have done your job. Go back and photograph Bukowski again."

The greatest challenge was calling Bukowski and having him
agree to another session. Almost the first thing he said was,
"What's wrong with those people? We must have taken a few
thousand pictures, kid. Why can't they put a story together?
Are they idiots?" I quickly explained that I needed him to give
me another chance. Since the art director was offering me
another shot, I hoped he would do the same and give me just
one more day—the beer would be on the magazine. Another
difficulty was finding a free Tuesday. Bukowski was an avid
horse gambler, and this was the only day that "nags" didn't
race in southern California. While he was still trying to decide
on a Tuesday, I told him that I was coming out to California
whether it suited him or not. Otherwise it would be the end of
my photographic career.

Two weeks later I knocked on his door. When Bukowski
answered, he looked hung over and said to me, "Who the hell
are you? Oh yeah, give me a couple of hours to recover but go
ahead and set up your equipment and be ready." More than two
hours passed. When he finally came down the stairs, his hair
was wet, his sunglasses were on upside down and he was wear-
ing a torn black t-shirt. He held up a large Bowie knife to my
face and shouted, "Is this what those f...ing krauts want?"
"Yes!" I shouted back. "Let's get to work." During that session
I shot my first photos to be published in the *FAZ Magazin*, and
I continued to work for them until 1999, when they stopped
publication.

From the time I shot my first story on Bukowski (p. 30),
through the memorable days I spent with Isaac Bashevis

Singer (p. 18) in Miami Beach and New York, from the time
I spent with Joe Cocker in his Santa Barbara hills retreat,
through the weeks spent with Roy Lichtenstein while he was
working on his seventy-eight-foot-high *Mural with Brushstroke*
on Seventh Avenue (p. 57), to my most recent shoot of Shirley
Maclaine (p. 36) in the hills and on the beach of Malibu, I have
never forgotten my early morning lessons with Pospischil at
the Algonquin.

 With gratitude and friendship, I dedicate this book to my
colleague, Hans-Georg Pospischil, who sent me to San Pedro a
second time.

Acknowledgements:
I also want to acknowledge the help of photographers and light-
ing experts who assisted me with the technical aspects of com-
pleting this work: Randy Brown, Steven Begleiter, Andy French,
David Maclay, Craig Morey, Pito Collas, Franco Vogt, Ludovic
Moulin, and most recently my son, Lucas, aged eight, who took
my photo for the frontispiece.

 I want to take this opportunity to thank Simon Crocker,
Philippa Hurd, Stephen Hulburt, Claudine Weber-Hof and
Iris von Hoesslin for making the experience of working on
this book a joyous birthing.

Abe Frajndlich
b. 1946, Frankfurt am Main, Germany
Resides in New York, NY

Education
1968 B.A. Northwestern University, Evanston, IL
1970 M.A. Northwestern University, Evanston, IL
1970-71 and 1975-76 Residency with Minor White, Chairman
of the MIT Department of Photography, Arlington Hts., MA
1974-75 Study and work with Nathan Lyons, Visual Studies
Workshop, Rochester, NY

Present Position
Freelance art and magazine photographer. Has worked for the
*Frankfurter Allgemeine Zeitung, ArtNews, Life, London Sunday
Times, New York Times Magazine,* and many other publications in
the U.S. and Europe.

Selected Solo Exhibitions
1999 FotoForum International, Frankfurt am Main, Germany
1998 Infocus Gallery am Dom, Cologne, Germany
 Museum Molkau, Leipzig, Germany
1997 Fotogalerie Kulturamt Friedrichshain, Berlin, Germany
 FotoForum Frankfurt, Germany
1995-96 Native Indian Museums—Traveling Show
1994 Leica Gallery, New York City, NY
1993 Thread Waxing Space, New York City, NY
 University of Delaware Museum of Art,
 Wilmington, DE
1990 Museum Ludwig, Cologne, Germany
 Jewish Community Center, Cleveland, OH
1983 Dayton Art Institute, Experiencenter Gallery,
 Dayton, OH
 Zenith Gallery, Pittsburgh, PA
1982 Akron Museum of Art, Akron, OH
1981 Bonfoey Gallery, Cleveland, OH
1980 Northlight Gallery, Peninsula, OH
1979 The Photography Place, Philadelphia, PA
1978 Image Co-Op, Montpellier, VT
1977 SohoPhoto Gallery, New York, NY
 Musée Nicephore Niepce, Chalon-sur-Saone, France
1976 Gallery of Photographic Arts, North Olmsted, OH
1974 United States Senate, Washington, D.C.

Selected Group Exhibitions
1999- *Photographic Portraits of the Artist since 1945,* curated
2000 by Michael Kohler, Museum Bad Arolsen, Germany,
 and traveling, eight portraits of Cindy Sherman, four
 portraits of Gilbert & George
1996 *Master Photographs from the Permanent Collection,*
 The Cleveland Museum of Art, Cleveland, OH, one pho-
 tograph + inclusive catalogue, 15 photographs
 Leica Gallery, two-person exhibition with Ralph Gibson
 Thinking Print, Books to Billboards, 1980-95,
 The Museum of Modern Art, New York, NY
1992 *The Essential Art: 140 Years of American Photography*
 from the Ansel Adams and Virginia Adams Collection,
 University of Arizona Center for Creative Photography
 traveling show
 La Photographie Dans Le Monde, Collection Musée
 Nicephore Niepce, Chalon-sur-Saone, France
 May Show, The Cleveland Museum of Art, Cleveland,
 OH, also 1989, 1988, 1986, 1982, 1981, 1979, 1977, 1974,
 1973
1984 *Inside Self Someone Else,* Dayton Art Institute,
 Dayton, OH
1983 *PhotoCollect,* New York City, two-person exhibition with
 Minor White
1982 *Young American Photographers,* The Art Museum,
 Princeton University, NJ
 Huntington College Art Gallery, Montgomery, AL,
 two-person exhibition with Chris Pekoc
 University of Florida Art Department Gallery,
 Gainesville, FL, two-person exhibition with Chris Pekoc
1981 *Second Sight-Infra Red Survey,* Carpenter Center,
 Harvard University, and traveling in U.S. and Europe
1981 New Gallery of Contemporary Art, Cleveland, OH,
 three-person exhibition
1980 *Personae,* Mather Gallery, Case Western Reserve
 University, Cleveland, OH
 Summer Show, Daniel Wolf, New York, NY
 The Automobile Image, MIT, Cambridge, MA
1978 Fotogalerij Paule Pia, Antwerp, Belgium,
 two-person exhibition
 Focus Gallery, San Francisco, CA, two-person
 exhibition
1977 New Gallery of Contemporary Art, Cleveland, OH,
 two-person exhibition
 Gallery of Photographic Arts, North Olmsted, OH,
 two-person exhibition with Ansel Adams
1976 Addison Gallery of American Art, Andover, MA
 G. Ray Hawkins Gallery, Beverly Hills, CA
 MIT, Cambridge, MA, two-person exhibition
1974 *Celebrations,* MIT, Cambridge, MA
1973 *Children: 1843-1973,* Exchange National Bank,
 Chicago, IL

Selected Collections

Akron Art Museum, Akron, OH
Bibliotheque Nationale, Paris, France
Centre Georges Pompidou, Paris, France
The Cleveland Museum of Art, Cleveland, OH
George Eastman House, Rochester, NY
John and Mabel Ringling Museum, Sarasota, FL
Museum Ludwig, Cologne, Germany
MIT, Cambridge, MA
Musée Nicephore Niepce, International Museum of Photography,
Chalon-sur-Saone, France
The Museum of Modern Art, New York, NY
National Portrait Gallery, Washington, D.C.
Tampa Art Museum, Tampa, FL
The Art Museum, Princeton University, Princeton, NJ
University of Arizona, Tempe, Center of Creative Photography
University School, Hunting Valley, OH
Victoria and Albert Museum, London, England
Visual Studies Workshop, Rochester, NY

Selected Corporate and Private Collections

Baker & Hostetler, Cleveland, OH
Peter Bunnell, Princeton, NJ
AGA Burdox, Stockholm, Sweden
Nils and Marina Burwitz, Valdemosa, Majorca
Nancy Dickenson, Santa Fe, NM
Joe Erdelac, Cleveland, OH
Exchange National Bank, Chicago, IL
Mr. & Mrs. Arthur Feldman, Cleveland, OH
Eikoh Hosoe, Tokyo, Japan
Huntington Bank, Columbus, OH
David Ireland, San Francisco, CA
Bill and Janet Jacklin, New York City, NY
Kopperman & Wolf, Cleveland, OH
Peter Lewis, New York City and Cleveland, OH
Gilbert Lloyd, London, England
Herbert Locher, Cologne, Germany
Senator & Mrs. Howard Metzenbaum, Washington, D.C.
Reinhold and Inge Misselbeck, Cologne, Germany
Ohio Savings, Cleveland, OH
Kurt Olden, New York City, NY
Hans-Georg and Bernadette Pospischil, Frankfurt am Main,
Germany
Progressive Corp., Cleveland, OH
James Rosenquist, New York City, NY
Standard Oil Corp., Cleveland, OH
Garner Tullis, New York City, NY

Monographs by Abe Frajndlich

Eros Eterna (Heidelberg: Umschau Braus Verlag, 1999).

Masters of Light, exh. cat. (Cologne: Museum Ludwig, 1990).

Lives I've Never Lived: A Portrait of Minor White (Cleveland, OH: Arc Press, 1983).

Cleveland Infra Red (Cleveland, OH: Publix Imprints, 1981).

Figments (Boston: self-published, 1975).

Paul Jay. *Abe Frajndlich.* Exh. cat. (Chalon-sur-Saone: Musée Nicephore Niepce, 1977).

Portfolios

500 CAPP, collaboration with David Ireland, John Ashberry, and Gunner Kaldewey, Kaldewey Press, Edition 46, 1995.

Glove, collaboration with painter Chris Pekoc, 12 photographs, ARC Press, Edition 50, 1982.

Homage to Yukio Mishima, introduction by Eikoh Hosoe, 12 photographs, ARC Press, Edition 35, 1980.

Entropic Freeze, introductory quote from Nathaniel West's *Miss Lonelyhearts,* ARC Press, Edition 35, 1980.

Cleveland Infra Red, introduction by Peter Lewis, 12 photographs, ARC Press, Edition of 60, 1980.

Lives I've Never Lived: A Portrait of Minor White, introduction by Douglas Neil Prudden, 12 photographs, ARC Press, Cleveland, Ohio, Edition 50, 1979.

Private Figments, introduction by Douglas Neil Prudden, 12 photographs, Boston, MA, Edition of 25, 1975.